PHOTOGRAPHY: CRITICAL VIEWS

Public Bodies – Private States

PHOTOGRAPHY: CRITICAL VIEWS

SERIES EDITOR
John Taylor

Department of History of Art and Design
Manchester Metropolitan University

This series explores the historical and contemporary uses of photography in sustaining particular social, class-located, institutionalised and gendered positions. Whereas modernist photographic history confined its study to the celebration of unique works of art produced by creative artists, this series shows how photographic meanings are produced in the social formation of knowledge. The series looks beyond the smooth narrative of selected 'masters', styles and movements. It rejects the idea that technology is the driving force spreading photography outwards. It refuses to allow the idea, found in illustrated history books, that photography is a straightforward 'window on the world'. The series aims to develop the subject area of photographic history, theory and criticism as an individual discipline. At the same time it crosses disciplinary boundaries and draws on the methods of art history, literature, film, cultural studies, anthropology and cultural geography to situate photography in its intellectual context.

Public Bodies – Private States

New views on photography, representation and gender

EDITED BY

Jane Brettle and Sally Rice

Manchester University Press

Manchester and New York

Distributed exclusively in the USA and Canada by St. Martin's Press

© Manchester University Press 1994

While copyright in the volume as a whole is vested in Manchester University Press, copyright in individual chapters belongs to their respective authors, and no chapter may be reproduced wholly or in part without the express permission in writing of both author and publisher.

Published by Manchester University Press
Oxford Road, Manchester M13 9PL, UK
and Room 400, 175 Fifth Avenue,
New York, NY 10010, USA

Distributed exclusively in the USA and Canada by
St. Martin's Press, Inc., 175 Fifth Avenue,
New York, NY 10010, USA

British Library Cataloguing-in-Publication Data
 A catalogue record for this book is available from the
 British Library

Library of Congress Cataloging-in-Publication Data applied for

 ISBN 0 7190 4120 1 hardback
 ISBN 0 7190 4121 X paperback

Set in Sabon and Trade Gothic
Design by Simon Meddings at Lionart
Printed in Great Britain by BPC Wheatons Ltd, Exeter

Contents

Foreword

Ludmilla Jordanova

THIS BOOK is more than an 'interdisciplinary' exercise that brings together different 'bodies of knowledge'. If it simply served to display relations, affinities between academic disciplines, it would be concerned with entities that are, essentially, similar. This is because, at one level, one discipline is pretty much like another. Art is not a discipline in the usual sense of that word, although it shares much, both in method and content, with conventional fields of knowledge. In fact *Public Bodies – Private States* does something more unusual in placing the work of feminist artists alongside that of feminist scholars. The resulting juxtapositions can and should be read in many different ways.

The ability of artists to be articulate about their projects has generally been valued, precisely because the study of art has had scholarly status for so long. It must be admitted, however, that for several centuries the model of artistic prowess, as of art criticism, has been profoundly gendered. Even if unravelling the senses in which these endeavours are 'masculine' remains challenging, the broader implications are clear. Women artists and critics are awkwardly placed, so to speak. This makes it vitally important that they are heard as well as seen, that their capacities to conceptualise art are acknowledged and respected. It is notable that the ability of academics, both male and female, to be 'poetic' or 'artistic' is viewed with considerable ambivalence. The recognition given to those who write literature, as well as teach it, is a striking exception. Furthermore, in Britain most of these are men. Within academe, we like to be able to pigeonhole each other by assigning clear institutional and disciplinary labels, and there is a tacit assumption, from which only a few 'stars' are exempt, that academic work remains just that unless one's expertise is directly relevant to external, usually political, events. In general, however, those who write about, in contrast to those who do, are all too easily viewed as deriving their life force by parasitic means, as taking not giving, as being removed from 'real life', defined in anti-intellectual terms.

From a feminist perspective it is easy to see why the commonplaces through which art and scholarship are distinguished are misleading. Both require an

imaginative effort that is nurtured by immediate experience and by what is limply referred to as cultural context. This is misleading because it depoliticises both endeavours. Feminist artists and scholars are likely to have shared interests, not just in so-called women's issues, but in their desire to criticise existing arrangements, to find new ones, and to feel at ease doing so. Collaborations like this one will help feminists both refine their common ground and explore the diverse perspectives their varied skills and practices give rise to. To say that art and analysis are complementary is not to deny the differences between them. None the less, their complementarity has a special importance for feminism.

The distinction between public and private, which is generally understood to be a fundamental polarity in Western intellectual traditions, has provoked strong reactions in feminists. However, these reactions are far more complex than is usually recognised. There has been a feeling that the distinction worked against women's interests in ways that needed to be understood as a matter of urgency. This was, and is, a political response. Equally striking is the rhetorical potential of the polarity – hardly a new discovery since eighteenth-century women writers were well aware of this, deploying it in elaborate and often surprising ways. Dated as the slogan 'the personal is political' may sound, its implications are still being worked through. Indeed it could be argued that current debates in the United States around the legal status of homosexuals and attempts to remove legal impediments to discrimination, give the phrase a fresh relevance, as do continuing battles around domestic violence. At the same time, it is now clear that the division between public and private is also a fiction, a construct. Analyses are thus needed to investigate how the division was created and constantly reinvigorated, what work it does, and why it was seductive when daily life so often ignored or rejected it. The intellectual frameworks that have been and are being used to understand what used to be called 'Woman' inspire feminists not so much to simple anger at 'oppressive dichotomies' as to explorations of the rich, entangled metaphors that constitute them. Public/private is one such metaphor. In a number of ways it is experienced as having a direct bearing on bodily experience and its representation, some of which are explored in the following chapters. Women artists, and I am thinking here particularly of Frida Kahlo, have been relentless in holding up for critical inspection the boundaries implied by these gendered polarities. This could be painful in every sense, as it was for Kahlo, who used her own gruesome medical experiences in such an explicit manner that the tortured

intimacy of her canvases still jolts the viewer.

Medicine, even more than the natural sciences, occupies a special role in the constellation of issues this book addresses: public/private, feminism, photography, power... It has acquired the legitimacy to see and intervene in what is construed as most private. It has long been a site of feminist struggle. It took on photographic techniques with enthusiasm for the supposedly unmediated vision they gave access to. It has generated metaphors of unusual potency. If anyone needs to be convinced of this they should see David Cronenberg's film *Dead Ringers*, which concerns twin gynaecologists and their relationship with their patients. This film mobilised most of the current ideas about gender and medicine, throwing in the theme of the double for good measure to show just how important the idea of duality is. Without doubt, those concerned with 'the body' need to pay particular attention to medical ideas, practices and representations.

It is precisely because 'body' is such a protean idea and because authoritative domains – law, science, medicine – theorise it that feminists have to keep interpreting it. But there are dangers. There is a cold form of abstraction in some modish treatments of 'the body' that is quite unhelpful in its disregard for historical specificity. And it is essential to be clear about the status that is being assigned to the profusion of metaphors that are related to it. It is quite possible to be playful with images of public and private, of gendered bodies; more than this, it is desirable to find how far you can go with them. At the same time it is equally important that the ways in which these terms function in specific societies are understood – a taxing task indeed. There are points at which these two projects intersect – this book is one of them – but it is also helpful to see the ways in which they differ. Both are born of feminist politics, but they elaborate those politics in their own ways.

Feminism is now the progenitor of so much, of so much that is confident, that it can underwrite experimental work of many different kinds. One result is the confluence that has made this book possible. It contains many pleasures, and will have achieved its aim if it permits other confluences to be imagined and realised.

Introduction

Jane Brettle and Sally Rice

WITHIN THIS publication the boundaries of Public and Private and their convergence in the site of the 'body' are at once suggested, located and problematised. The body, essentially private as the realm of our most intimate experience, is also public, as spectacle and the medium through which common experience is realised and represented, whilst the State, as an external embodiment of authority and power, is a determining factor in our personal histories and everyday lives. The convolutions of these relationships are mirrored within the structure of this publication where the poetical and theoretical, visual and linguistic are juxtaposed as they work through their different but related concerns and method. In this way any authoritative voice is denied – in keeping with contemporary emphasis on the re-thinking of traditional Western thought, a suggestive practice seeks to generate new forms. By touching upon and using established theories alongside the personal, the position of academic distance is confounded whilst the specific history, location and restrictions of writing are acknowledged.

In the essay by Yve Lomax the concept of the private and individual intervenes in the apparently universal laws of science, frozen within the photographic moment. The presence of historical influence is continually felt yet as the personalities of these myths are detailed a shift takes place. These grand narratives weave in and out of personal life – placed alongside stories of the everyday, their own roots in the particular and mundane are uncovered and their claim on universal truth gives way. This is not to say that their poetry is diminished but that the power with which they are invested can be diminished by a little 'healthy disrespect' (Chatelet 1973). The possible implications of this power are shown in Alison Young's *Caveat Sponsa*, which considers the influence of public law upon private life which in turn generates certain social structures supportive of this power base to which the individual and the community are increasingly subjected. The effectiveness of this power structure is seen as dependent upon the function of our language as the law which determines the mechanisms of contingent systems and the construction of personal and public life.

Differing in their priorities and approach, both these essays declare their own

specificity, in this sense insisting upon the presence and need for other voices.

Contemporary society is constituted through a range of highly theorised fields; consequently knowledge of medicine, health, the physical laws of the universe, architecture, theology and the law have been formalised within institutions. Historically, connections between these realms have always been recognised but the structure of such relationships is often that of 'appropriation' rather than 'exchange'. In the present climate of rationalisation where discovery generates patency there is a pressure to conceal any currency of knowledge. Carefully constructed linguistic systems help these 'academies' to maintain their cultural and economic significance, forming separate establishments, industries and corporations. In this sense knowledge has become privatised – only available to us, the public, through carefully monitored systems, mediated by professional experts.

Our education system supports this practice: specialisation requires a process of selection which means that from a comparatively early age fundamental areas of knowledge become alien – *other people's business*. This exclusive learning process, together with competitive practice, ensures that we begin our progress towards social and economic independence by developing defensive positions which discourage dialogue and intervention from outside.

Of course, some classification of knowledge is necessary – a kind of organisational economy is demanded in our social undertaking to ensure the widest possible growth in knowledge. The result, however, is that this growth is in a particular direction and that for each individual information concerning their most intimate and everyday experience, as well as more public and social concerns, comes from without. Knowledge has become *Other*; an external representation. In Mary Grey's exploration of truth and knowledge we glimpse how convention, anxiety and power have played their part in determining what this knowledge might be. The limitations of our existing logic have become increasingly clear in the last decade; with the loss of an opposing term the dependence of the powerful nations on this linguistic pivot can be seen and felt. In this demand for a new practice of knowing and listening, the process of re-imaging and re-thinking places the individual alongside the global in a re-distribution of attention and movement away from a language of binary opposition (upon which the concept of a public/private divide relies) to a nurturing practice and economy of difference.

Since the early 1970s photographic theories have emphasised ways in which the

medium of photography has been used by our dominant institutions. As fine art object, historical and contemporary evidence, social document and personal history it has finally transcended classification. Photographic images have been publicly eulogised, criticised and scrutinised – privately treasured, idolised and fetishised. It is recognised that the camera is used by everyone, from private investigators to princes, holiday-makers to advertising agencies.

Our televised experience is of images transmitted in an endless telescoping of events, information and entertainment. Photographic representations of war zones and wildlife, global disaster and personal triumph explode into our living-rooms and redefine the space between a lived and simulated experience (Virillio 1986). This cathode 'eye' which continually exposes itself in the privacy of our home, insidiously exposes us in more public places and (re)presents us to ourselves as monitored, always on display. Delineating both our public and private domain this 'instantaneous experience' also reminds us that all over the planet the same 'moment' is being both captured and experienced by someone else, and that a 'point of view' depends upon the cultural experience, the particular 'I' of the individual photographer or viewer. The historical and circumstantial perspectives to which this 'I' is subject is explored in the essays of Elizabeth Wilson and Christine Battersby.

The work of both writers and artists emphasises the mechanics which have shaped our vision. These interpretations are, of course, themselves positioned by that past. What is vital here is that the understanding expressed is that of women, whose historical presence has been that of Other and whose 'vision' has been excluded or disempowered. What is significant about our contemporary scene is the insistence by previously disenfranchised groups on their visuality, their public presence and their contribution to social and cultural practice. As Christine Battersby acknowledges in relation to artistic work this has to involve a readdressing of the conditions and criteria which have shaped our aesthetics.

That a point of view can be understood as both the experienced 'I', and the 'eye' which 'looks out' and optically defines the public space has ramifications unique to photography and other photo-related media within the visual arts.

When we look through our physical eye we are forced to accept that the perceived reality is always, by necessity, framed by the mechanics of vision. More recent theories have examined this *optical illusion* and inform us that the retinal image can never be compared to the actual object, we are unable to 'see' outside the world of

imitations, of representations.

If we imagine this mechanism duplicated by the camera lens then a photographer is caught within a double bind. There is both the recognition of the limitations of the optical frame and a drive to *capture* the 'object of desire' (Žižek 1991). Through this *scopic vision* our outwardly shared experience is not lived, but imaged; internalised as a more enduring replacement for the 'real'.

In the photographic image it is possible to experience a multitude of responses and yet we know it represents the impossibility of defining what is 'real'. It is a matter for debate whether these images will ultimately be replaced by the seamless representations of new technology. Photographic 'truth' has never been absolute, but in its various attempts to intervene in and celebrate political and personal lives it offers access to a particular view of human states.

Once we question the photographic 'moment of truth', it is possible to consider the moments before and the moments after the shutter is released – we are free to explore the possibility of a photographic 'movement' and 'intervention' in time.

Recognising the mechanisms intrinsic to photography presents the opportunity to transgress the optically and historically constructed frame. By intervening in photographic space and time we are able to *focus* on other versions of this *window on the world* and harness the ironies present in reading photographic images. Our contemporary experience of the world involves continual interactions with both images and words. Communication oscillates between these two forms: as inescapable as our bodies, we are always in the realm of language and never outwith representation. This position is common to the various disciplines used in our classification of knowledge. When we strive to understand the mechanisms of language and representation we begin to question the process which has restricted any principle of integration to the realm of the imaginary. Always idealism rather than ideology, 'looking at' and 'listening to' the language of different cultural processes has yet to be fully embraced by our organisational systems. To propose such a practice is to begin to dislocate our established maxims and even individual fixations.

The juxtaposition of visual and written texts in this publication is offered as an intervention in this practice of division. By sharing and acknowledging interest and common concern whilst allowing difference to remain exactly that, the rigidity and anxiety which often surrounds artistic and academic work will be avoided and the 'space' created by this placement of related visual and written texts will be full of

meaning rather than void.

As private citizens, public positions cannot always be sustained – inevitably private space eclipses public responsibilities and concerns. Equally, a private moment is only so by chance; the notion of private fantasy can itself become fantastical. Like the constantly evolving public sphere we also inhabit evolutionary bodies – evolutionary in themselves as we develop new abilities, experience illness and health, birth, physical development and age we are continually (re)defined and (re)construct ourselves to negotiate our new locations.

In this publication, a body moving within these structures provides a model which supports new undertakings in the development and dissemination of knowledge and ideas. Such a body does not represent one uniform model; whilst it can only claim to represent the cultural positions, experience and language of its producers, it brings together diverse possibilities. The body is the point of their convergence. By encouraging a matrix in which interconnections and differences are recognised and collisions and juxtapositions facilitated we might generate a space for invention and intervention where the attractions and reactions between diverse bodies can become visible.

Bibliography

Chatelet, Francois (1973) 'La philosophie des professeurs', Paris, cited by Rosi Braidotti in *Embodiment, Sexual Difference, and the Nomadic Subject, Hypatia*, 8,1, Indiana University Press, 1993.

Virillio, Paul (1986) *The Over Exposed City*, Zone, Cambridge, Massachusetts, MIT Press.

Žižek, Slavoj (1991) *Looking Awry: An Introduction to Jacques Lacan through Popular Culture*, October Books, Cambridge, Massachusetts, MIT Press.

Bodies in Public and Private

Elizabeth Wilson

THIS ESSAY approaches the relationship of bodies to space from the perspective of cultural history. With the current dissolution of 'discipline' boundaries; history, cultural studies, sociology and literary studies have fertilised one another. This has made new approaches possible, and put an emphasis on representation and discourse in the discussion of topics such as urban space and the body.

Since the early nineteenth century the contrast between city and country, civilisation and nature has been one of the main organising principles for the way we make sense of our visible world. The Romantic movement provided a powerful response to the industrial revolution and the attendant growth of cities, encapsulated as the contrast between William Blake's 'satanic mills' and 'England's pastures green'.

This binary opposition has remained with us ever since. In the 1900s the Garden City movement made popular an architecture of cottages and village streets, perpetuated in the suburbs of the 1930s – and indeed, in today's post-modern supermarkets and housing developments. For other reformers, parks and annual holidays were to provide an escape from the stress of city life, even as country-dwellers flocked to the towns not only for work, or because they had been turned off the land, but also because they believed the streets might be paved with gold, or filled with forbidden excitements.

Although the rural areas were, of course, populated, one abiding distinction between urban life and life in the countryside has been the emptiness of landscape as opposed to the bustle and crowd of the city street. 'Figures in a landscape' is a common representation of the way in which people were supposed to inhabit the countryside. Isolated, although not usually in a threatening way, these figures, singly or in twos and threes, harked back to a pastoral, bucolic tradition, and could engage in peaceful contemplation among undulating pastures and parks or sublime crags and torrents. The image is one of tranquillity and repose, of oneness with a deity or at least with Nature. Nature, of course, had little to do with it when landscaping the private land of England. At Petworth House in Sussex, Capability Brown uprooted cottagers, dug lakes and raised hills in order to create just such an image of picturesque,

reposeful nature.

Examples of the painting of rural life as a reposeful idyll are to be found in the work of John Wilson or John Sell Cotman – although there are many others. Painters such as Cotman depict agricultural workers, but they are idealised; they too are part of the rural harmony (quite unlike the later oppressed peasants of a Courbet or a Millet).[1]

In this painterly tradition the mid-nineteenth-century photographer Henry Peach Robinson, who incidentally despised country folk, used models and montage to depict a 'naturalistic' rural idyll. By contrast, the Norfolk doctor Peter Henry Emerson, considered photography an art form independent of painting, which could reveal the inherent 'truth' and poetic rhythm of pastoral Norfolk life. Often described as the 'father' of modern photography, his idealistic images excluded the effects of social and economic change which were dramatically altering the appearance and reality of life in the Norfolk Broads at the time.

The picture of urban life, when it gets under way, creates an utterly contrasting world. T. J. Clark (1985) has shown how Edouard Manet brings the city

Alexander Nasmyth.
Highland Landscape

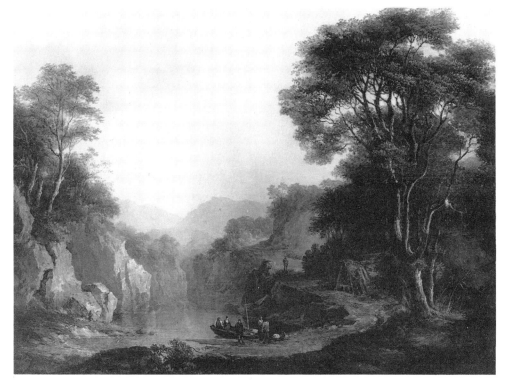

even into his paintings of the countryside around Paris; factory chimneys rise in the distance. Even more interesting to French painters of the second half of the century were the *banlieues* or outskirts, where the end of the city mingled with the beginning of the countryside to create a strange and melancholy region. Central to the painting of 'modern life' (as Charles Baudelaire put it) was an Impressionism that converted what had been thought of as the ugliness of the urban – smoke, railway stations, crowds – into a new kind of beauty. Delineating this new beauty of ugliness, the French journalist, Camille Mauclair, writing soon after 1900, described the plain of St Denis (an industrial quarter of Paris) 'with its thousands of smokestacks, its smelting fires, its innumerable beacons, its interlaced highways where from all sides spreads the beautiful mother of pearl smoke which the twilight embraces' (Mauclair 1982).

By contrast, photographic representations of urban and industrial life revealed the appalling conditions of inner-city ghettos and called for reform and social consciousness. In Scotland The Glasgow City Improvement Trust commissioned Thomas Annan in 1868 to photograph the streets and wynds of central Glasgow designated for demolition. These images, intended as information for those too genteel to enter, showed the terrible conditions endured in the working-class slums. In America in 1890 the social reformer Jacob Riis made extensive use of photographs in his book about the New York tenements, *'How the Other Half Lives'*. Later, Lewis Hine recorded the squalid conditions of immigrants arriving from Europe and, encouraged by Arthur Kellogg, toured America recording the plight of child labourers.

Above all, though, there are the people, or rather, the crowd. In the painting of the nineteenth century this crowd is often celebrated. It glitters, it triumphs, there is a gorgeousness, a rush of energy and a heady sense of freedom and excitement in paintings by Manet, Renoir and Pissarro.

In the crowd the individual lives more intensely. The crowd represents vitality and joy. It is this side that tends to be represented in the light-filled paintings of Renoir and his compatriots.

Yet there is another and more sinister side to the crowd. Friedrich Engels wrote of its inhuman indifference in the 1840s. For Edgar Allen Poe it was imbued with an uncanny horror. His *'man of the crowd'* could exist only so long as he swam in the crowd – the crowd represents a new element which creates its own form of life, a form of life that is both parasitical and trapped (Poe 1984).

More commonly the crowd was experienced as uncivilised, unclean and

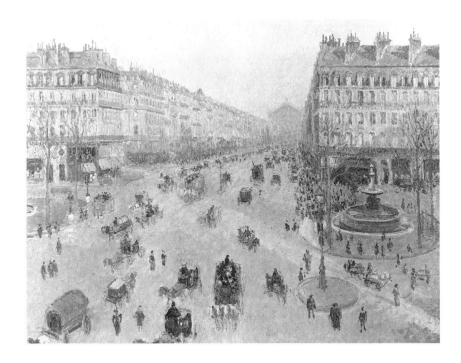

Camille Pisarro.
*Avenue de l'Opera, soleil,
matin d'hiver*

dangerous; and often described in feminine terms, as hysterical, carried away by emotion, or in images of feminine instability and sexuality, as a flood or swamp, engulfing and suffocating (Huyssen 1986). Even at its best, the crowd is overwhelmingly worldly, drawing the individual away from his highest, spiritual self, away from contemplation and into consumerism, away from wholeness and vision and into the trivial and fragmentary. There is not stillness, but movement; not eternity, but time flashing by.

If the function of the figure in the landscape emphasises its emptiness, and the individual rests in this solitude, the crowd in urban space spills over, overwhelms and bursts through the intended order of city streets and squares. Perhaps the medieval city had been a city of wynds, courts and alleys, more like an organic entity – a sponge – than a planned and logical *habitus*. By the nineteenth century, however, baroque conceptions of the orderly, spectacular and 'open' city – open that is to surveillance – were available. Yet the great cities of the nineteenth century did not seem to fit this blueprint. They had become just too large, too dirty, the haunt of criminals and the sexually deviant.

As a dangerously proliferating and uncontrolled space, the nineteenth-and early twentieth-century city was subject to concentrated governmental intervention, reordering and regulation. The swamp must be drained. Cities were too large, and Ebenezer Howard, whose plan for a Garden City was realised at Letchworth, Hertfordshire, and then at Welwyn Garden City in the 1920s, argued influentially for cities that were smaller in size and therefore of liveable proportions (Howard 1898).[2] Edward Bellamy's *Looking Backward* (1890) inspired many radicals. His book described the City Beautiful of the year 2000, a perfectly ordered and zoned space.

These imaginary cities were notable for having wiped out slums, crime, poverty. They had done away with all that was negative about urban life. Their positive vision of what the ideal city *should* be like was more conservative. Although Letchworth included a few dwellings designed for semi-collective living, the distinction between private and public was not challenged. There is nothing in *Looking Backward* to suggest any change in the relations between the sexes, or that women will play a more forceful role in public life, although independent and bohemian women were drawn to the real-life Letchworth (Wilson 1991). The city-dwellers are simply organised more effectively into workers, consumers (women) and managers. By 1900 Bellamy had none the less attracted a large following of architects and town planners eager to construct the City Beautiful.

The United States had hosted many utopian experiments in collective living, most of which were away from big city centres, but the 1860s and 1870s also saw the development of experiments in apartment living for the middle classes, which drew on a diluted form of utopian ideas. The Hotel Pelham in Boston, designed by Arthur Gilman, and the Stuyvesant Buildings in New York, on 18th Street, designed by Richard Morris Hunt, were among the most luxurious, intended for the wealthiest sections of society; while Haight House in New York had a communal kitchen, dining-room and laundry, twenty family units and fifteen 'bachelor' suites, and became 'the chosen refuge of artistic and literary people' (Hayden 1981), women as well as men.

Life on her own in the great city was always more difficult for a woman than for a man, of course. Women in the nineteenth-century city were the bearers of much of the anxiety surrounding city life in general. The female body represented the private in public space. The enormous nineteenth-century preoccupation with prostitution suggests that at some level a woman in public – a public woman (as prostitutes were called) – was for the Victorians a living representation of sexuality, and should

therefore have been hidden. Women *were* their bodies; and whereas a feminine body was seemly and appropriate in a rural landscape – since women were closer to Nature anyway – a woman in the public spaces of the city was a threat and a danger. She should not be there; she polluted public space.

It is commonplace to argue that the coming of industrial society greatly intensified the pre-existing division between public and private. Philippe Ariès (1973) is only one influential historian to have insisted on the growing importance of the public/private divide from the seventeenth century onwards.[3] The expansion of the private sphere was meant to swallow women up. That it did not completely succeed in doing this caused perceived moral and political problems.

Franco Moretti (1983: 127) has argued that:

> the great novelty of urban life...does not consist in having thrown the people into the street, but in having raked them up and shut them into offices and houses. It does not consist in having intensified the public dimension, but in having invented the private one – and especially in having transferred the meaning of individual life...into this new domain.

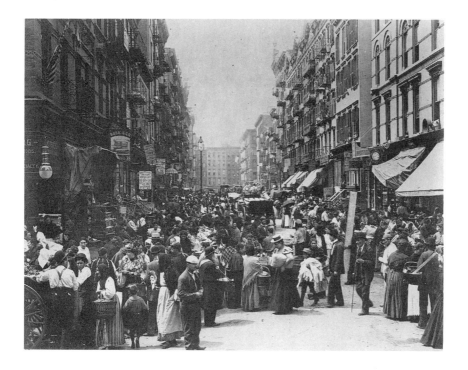

Byron.
Orchard Street, looking south from Hester Street, 1898

He is right in suggesting that the private domain became the site of personal and emotional life. Since women stood for the emotions and for private and individualised response to life (only men, according to the philosopher Hegel, could relate to abstract *public* concepts of justice and morality), their presence in the public sphere of the street, the park, the theatre, was cause for alarm. Their amorality eroded 'public morality'.

A further feature of urban life in the nineteenth century and today was, and to some extent remains, the close proximity of extremes – filth and wealth, begging and luxury, violent pleasure and violent crime. Yet Moretti also observes (1983: 117) that in fact city life operates against this dichotomy:

> to be suspended between unswerving habit and sudden catastrophe is much more typical of traditional rural societies... By comparison, city life mitigates extremes and extends the range of intermediate possibilities: it arms itself against catastrophe by adopting ever more pliant and provisional attitudes. It is no accident that the city dweller has always appeared as a typically 'adaptable' animal.

I would argue that the line was ideologically drawn more firmly and rigidly between the public and the private spheres precisely because in practice the line was blurred. In theory – 'in ideology' as Janet Wolff has expressed[4] – women were locked into the private sphere; in practice women passed through the city streets, massed through the working-class districts and haunted the many intermediate zones created by the industrial city.

These intermediate zones blurred the lines between public and private in spatial terms. The department store (an important invention of the nineteenth century), the public library, the restaurant, the cafe, the hotel lobby and even the office were, theoretically, public. Yet in many cases they aimed to recreate private zones. The department store was *like* a private house (Miller 1981) just as the cafe was *like* a salon, a 'home for the the homeless' as Siegfried Kracauer identified (1937). The relationship between boss and secretary was a pale replica of marriage.

Revisiting New York City in 1907 Henry James remarked on the 'truth that the present is more and more the day of the hotel', and not only that. The hotel, he observed, had become 'a complete scheme of life'. Yet it was, in a way, an imitation of life. In order to participate in the life of the hotel, to sit in its salon, to parade your

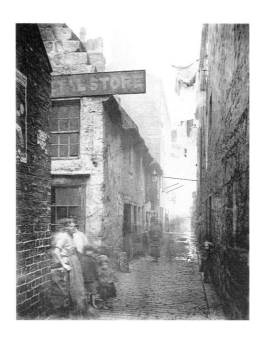

Thomas Annan.
Old Vennel off High Street

fashionable costumes, to be waited on by its servants, you had only to have sufficient money. Unlike the private house, the hotel was not truly exclusive. The means to pay rather than breeding or friendship was what gave the 'guest' (in fact, a customer) the right of entrance to these fake mansions.

Writing two years earlier than her friend Henry James, Edith Wharton, in *The House of Mirth* (1905: 298–302), also dwelt on the moral ambiguity of hotel life:

> The environment in which Lily found herself was as strange to her as its inhabitants. She was unacquainted with the world of the fashionable New York hotel...through this atmosphere of torrid splendour moved wan beings...without definite pursuits or permanent relations, who drifted on a languid tide.

Here, the moral ambiguity of the hotel is explicitly linked to the presence of women. In the 1920s the German writer Siegfried Kracauer, who was associated with the Frankfurt School, wrote of the hotel lobby as the home of the private detective, that quintessential 'man of the crowd'.[5] He observed that loitering (again a quintessentially urban occupation) is legitimate in the hotel lobby, and the private detective is the ultimate loiterer or *flâneur*,[6] a rootless urban character, an observer

with little or no 'private' life of his own. Women, of course, found it much more difficult to loiter without being suspected of soliciting.

Yet the presence of women in more clearly public places, streets and cafes, for example, itself contributed to the blurring of the line between public and private. A number of nineteenth-century writers, notably Georg Simmel and Karl Marx, have described the way in which money becomes the universal means of circulation of value, but is a medium divested of all moral content. The indifference, the amorality of money, is a well-worked theme. The circulation of women through city streets had the opposite effect: to make them morally ambiguous, tainted. If money was a colourless medium and its commercial circulation part of what blurred the division between public and private in the city (by creating commercial zones which provided phoney privacy and the illusion of a luxurious personal 'home'), the presence of women once again stained the fluidity of street life. As Henry James (1907) noted of the Waldorf Astoria, hotel life broke down all barriers, provided you had the wherewithal to pay. There was also the requirement that the guest appear respectable. Yet the appearance of respectability was all that was demanded:

> the condition, for any member of the flock, that he or she – in other words especially she – be presumably 'respectable', be, that is, not discoverably anything else. The rigour with which an appearance of pursued or desired adventure is kept down – adventure in the florid sense of the word, the sense in which it remains an euphemism – is not the least interesting note of the immense promiscuity.

This 'immense promiscuity' is at the heart of urban life. It is an ambiguous promiscuity, it is neither moral nor immoral, but amoral. It consists, in part, of the circulation of hundreds of thousands of bodies in often confined spaces, without personal contact. This extraordinarily elaborate quadrille produced what Simmel (1950) described as 'the blasé attitude'. The city-dweller has seen everything and nothing can surprise him.

Yet woman's relationship to this remains uneasy. Cast in the role of the one to be looked at rather than the one who looks, her body, decorated with garments that draw attention to it rather than rendering it uniform, which is to an extent the case with male fashions, is too much on display, and disrupts the flowing, colourless and all-embracing 'promiscuity' through which she moves.

In the late nineteenth century sociologists for example Simmel emphasised the anonymity, machine-like routines, rootless *anomie* and alienation of the great city – the metropolis – an attitude taken to extremes in Franz Kafka's novels. In practice, we may question whether individuals really experienced urban life in this way. Most people lived in familiar districts where they led elaborate social lives within a network of kin and friends. There have been then, and later, many descriptions of urban life as more like village life than Simmel could acknowledge – the ethnographic descriptions of London's East End after the Second World War by Peter Townsend, Michael Young and others (Young, Willmott 1952; Townsend 1957), the recreation of life in a working-class district of Leeds by Richard Hoggart (1957), and Jane Jacobs' account (1961) of Greenwich Village in the 1950s are some examples, while James Joyce had created a powerful sense of the familiarity and conviviality of Dublin in *Ulysses* (1922).

The view of urban life as alienated nevertheless caught the imagination of planners – and of many city-dwellers. In the twentieth century, withdrawal, first to the suburbs, more recently to smaller satellite towns and even to revamped villages, has been the answer to the threat of urban life, the paranoia it induced. There has been a gradual abandonment of city centres in favour of decentred urban regions.[7]

The domestic suburb was originally the place where women were supposed to be. Suburban life was, in theory at least, a sylvan idyll closer to rural than urban life. Yet even in the 1930s and 1940s many writers condemned the suburb, perhaps snobbishly, for its fake gentility and its way of being neither one thing nor the other. Today, that rejection has been carried forward into searing attacks on the postmodern urban or suburban corridor. Fredric Jameson (1984), for example, writes of 'the extraordinary surfaces of the photorealist cityscape, where even the automobile wrecks gleam with some new hallucinatory splendour'. He states that:

> The exhilaration of these new surfaces is all the more paradoxical in that their essential content – the city itself – has deteriorated or disintegrated to a degree surely still inconceivable in the early years of the twentieth century, let alone in the previous era. How urban squalor can be a delight to the eyes, when expressed in commodification, and how an unparalleled quantum leap in the alienation of daily life in the city can now be experienced in the form of a strange new hallucinatory exhilaration.

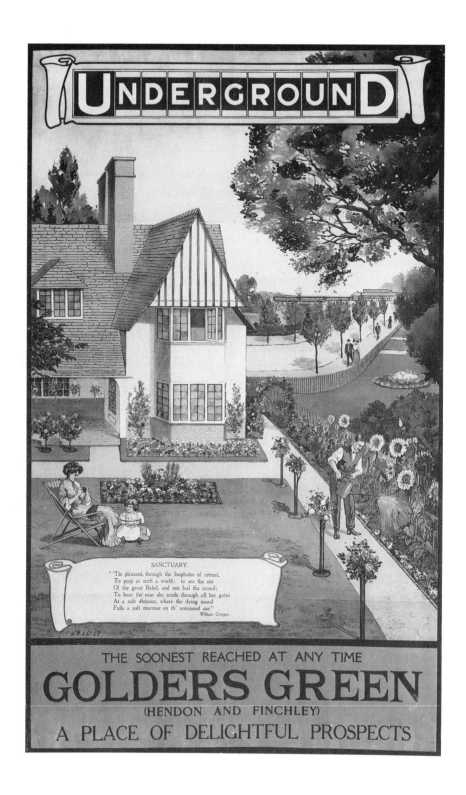

He rhetorically created a cityscape of schizoid clarity. He describes a (de)realised, centreless urban/suburban 'region', and suggests that the human response to this is a 'waning of affect' – where horror should be, there is only a blank smile or even pleasure. At the same time, he argues, contemporary art appears unable to represent these spaces and the human body in the same artwork. There are paintings of empty rooms, installations of automobile wrecks – and somewhere else there are paintings or polyester sculptures or doctored photographs of the human body, but the bodies and the spaces do not come together.

Jameson argues that this alienated cityscape prefigures the 'radical eclipse of Nature itself' (and his whole article is a sustained piece of special and highly rhetorical pleading, or indeed, an almost novelistic description of a dystopia, as well as an argument). Yet (thinking of Petworth House and eighteenth-century landscape painting again), Nature has been a cultural construct for hundreds of years. Rather than suddenly disappearing, Nature has its own postmodern version in the shape of theme parks, heritage venues and 'nature reserves'.

Even if Nature itself is 'radically eclipsed', this has not erased the binary oppositions whereby we structure our understanding of space. As stark a distinction is maintained as ever between new, or at least revamped, contrasting zones, which, moreover, retain their gendered identity. Now we have a Laura Ashley version of 'countryness' in cosy little towns and commuter villages. In Britain, areas as far away from London as Worcestershire have become commuter regions for workers who, while attached to metropolitan firms, can do some of their work at home and need travel into London only two or three times a week. Out-of-town hypermarkets and alternative centres of business and commerce have drained populations away from the capital and other huge cities. Small towns like Canterbury (to pursue the British example, although this is an international phenomenon) propose a domesticated and essentially 'feminine' world of tradition and family life (even if families are less likely to be nucleated in the traditional way). By contrast the decaying inner-city regions and 'sink estates' of the old metropolitan centres from which the population leakage has been greatest, have developed a kind of masculine inhumanity. In practice, it is women, children and the old, most of whom are women anyway, who are most likely to be trapped in the urban ghettoes, but the presence of large numbers of unemployed young men is what creates the ambience and sets the scene. Here, the American city experience is the most extreme and the most dramatic, brought to life – romanticised,

even – in that most urban of all literary genres, the hard-boiled private eye thriller. It is of interest that Raymond Chandler in his classic LA thrillers tended to dwell on the eerily bright suburban aspect of his chosen city, although he also described the seedy, rundown Bunker Hill section of LA:

> Bunker Hill is old town, lost town, shabby town, crook town... In the tall rooms haggard landladies bicker with shifty tenants. On the wide cool front porches, reaching their cracked shoes into the sun and staring at nothing, sit the old men with faces like lost battles. In and around the old houses there are flyblown restaurants, alien fruit stands and cheap apartment houses and little candy stores... And there are ratty hotels where nobody except people named Smith and Jones sign the register... Out of the apartment houses come women who should be young but who have faces like stale bee...worn intellectuals with cigarette coughs and no money in the bank... (Chandler 1943).

Chandler's LA, nonetheless, is still a city of dreams, and his small-time crooks and loose women have missed out on what the more successful seem to have acquired.

By contrast the Los Angeles described with fascinated horror by writers today has become almost the real-life equivalent of an amusement arcade game in which an urban desert is populated only by gangs of men bent on killing one another. In today's thrillers, LA is not even a twisted dream, it is a straight nightmare:

> Our destination was a beach town a few miles south of the airport in an area tainted with poverty. To the east, the ghetto communities of Compton, South Gate, and Lynwood were rigidly subdivided into gang turfs where some fifteen to twenty homicides marred the average weekend. Here, there were only endless drab buildings decorated with angular territorial declarations thrown up...with cans of spray paint... The streets were littered with trash and old tyres... A dilapidated sofa sat on the curb as if waiting for a bus. Listless ghetto warriors loitered near a corner market... Every third storefront had been boarded up (Grafton 1991: 131).

Mike Davis in his brilliant account of contemporary Los Angeles speaks of the new ghettoes as 'carceral society' (a term coined by Michel Foucault – society as prison). Davis describes on the one hand the way in which the ghettoes have become war zones in the manner of Vietnam, with Los Angeles Police Chief Daryl Gates on record as

saying that 'We're out to get them ... This is Vietnam here.'

> The 'them' – what a local mayor calls 'the Viet Cong abroad in our society' – are the members of local Black gangs, segmented into several hundred fighting 'sets' while loosely aligned into two hostile super-gangs... In the official version, which Hollywood is incessantly reheating and further sensationalising, these gangs comprise veritable urban guerilla armies organised for the sale of crack and outgunning the police with huge arsenals... Although gang cohorts are typically hardly more than highschool sophomores, local politicians frequently compare them to the 'murderous militias of Beirut' (Davis 1990: 268).

On the other hand, up in Beverly Hills and in all the desirable outlying middle-class residential areas, space is privatised, literally. The roads are private, often gated, and patrolled by private armed guards. In the city centre new, dead, corporate buildings create another kind of fortress environment. As a result:

> The universal and ineluctable consequence of this crusade to secure the city is the destruction of accessible public space. The contemporary opprobrium attached to the term 'street person' is in itself a harrowing index of the devaluation of public spaces. To reduce contact with untouchables, urban redevelopment has converted once vital pedestrian streets into traffic sewers and transformed public parks into temporary receptacles for the homeless and wretched. The American city...is being systematically turned inside out – or rather, outside in. The valorised spaces of the new megastructures and super-malls are concentrated in the centre, street frontage is denuded, public activity is sorted into strictly functional compartments, and circulation is internalised in corridors under the gaze of private police (Davis 1990: 224).

Meanwhile, as Davis points out, our traditional sense of privacy and the private sphere is invisibly breached by electronic surveillance, the sale of databases and subscription cable services.

It therefore no longer makes sense to talk about public/private in the old way. In referring to electronic surveillance Mike Davis appears to imply that it constitutes a violation and that our privacy should be preserved. Yet there have been many demands from feminists for breaches in the privacy of the private. Feminists have insisted on revealing the extent of hidden domestic violence, by men against women, against children, and, recently, child sexual abuse. These long-hidden, shameful acts

have been 'brought to light', and one result has been ever-increasing state intervention in the privacy of the family.

More generally, a literary, filmic and artistic obsession with 'showing everything' has led to no-holds-barred descriptions of sexual acts, sexual violence and bestial murders. Madonna's latest offering, *Sex*, is tame by comparison with the horrors of Bret Easton Ellis's *American Psycho* or Helen Zahavi's repellent *Dirty Weekend*, a novel in which a woman goes on a killing spree to avenge herself against men. (Strangely some feminists praised this book, which indulges in explicit scenes of violent sex, repeatedly culminating in the murder of the male participant). Is any role reversal, then, to be applauded, and should feminists have formed support groups for Peter Sutcliffe if he'd been a woman? *Dirty Weekend* reads more like an average exploitation novel than a feminist account, and at best is trying to have its cake and eat it. Significantly, it is apparently to be made into a big-budget film by Michael Winner, not exactly well-known for his feminist credentials.[8]

Meanwhile, artists like Jeff Koons create kitsch representations of sexual intercourse, and films routinely contain 'torrid' sex scenes. Without necessarily objecting to explicit representations of sex, it is important to try to understand their meaning. Why is it so important to Western culture at the present time to 'see everything', to have nothing 'veiled'? I am unable to answer this question, but can only note that such representations constitute a transgression of the public/private divide, which supports my argument that we can no longer think about it in the nineteenth-century terms that are still common currency.

Changes in fashion also play with the transgression of this boundary. On the one hand, beachwear is worn in city centres, and women's underwear has been turned into outer wear by Jean Paul Gaultier (who has influentially designed costumes for Madonna). There is no longer anything even remotely shocking about the sight of corsets, bras and tights with nothing over them worn at parties, dresses designed on the lines of an underslip, or shorts that look like French knickers. On the other hand, there has been a crossover between fetish wear and ordinary fashion, with leather and even rubber used to create mass fashions which – apart from the merest *frisson* or the *risque* – have entirely lost their association with deviant sexuality.

If it is true that postmodernism inaugurates a new experience of the world as fragmented, and that the postmodern sensibility breaks down divisions of all kinds – between high art and popular culture, between core and periphery, between dominant

and oppressed groups (one of the more fanciful claims) – then we should not be surprised that it breaches the public/private divide, bringing in public sex and private streets, open prisons and closed parks, cities in the countryside and open deserts.

In a sympathetic critique of Michel Foucault, Martin Jay (1986) has argued that the Enlightenment privileged looking and the ocular; sight was considered the most noble of the senses. In the twentieth century, however, he suggests that this has been reversed, and the dominance of vision has become suspect, causing paranoia, suspicions of voyeurism and a rejection of the mastery that sight once implied. To look and to see was part of the mastery that science claimed – dissection of the body being one of its most controversial aspects. Today, we have become suspicious of science and its claims as well, yet the gaze has become even more important in an image-dominated culture. In the city, however, this looking has no connection with the grand state spectacles of the baroque city or the city beautiful; it is the personal, individualised looking of the consumer, the shopper. New urban regions, are, indeed being created in which there is hardly any public space at all, no vistas, no monuments. By contrast, we display our individual selves, our individual bodies more.

Some feminists would argue that the voyeurism of visual culture places the female body as even more the object of the gaze than ever before, the view most influentially put by Laura Mulvey (1975: 6–18), although contested or modified since. I should prefer to stress the ambiguity of meaning created by female display, which is not necessarily passive.

The ambiguities of contemporary space may suggest the disintegration of our traditional ways of ordering our culture. A profound change does seem to be under way. At its present stage we demand and are able to 'see' more and more, yet instead of producing the enlightenment confidently expected by the eighteenth- and nineteenth-century scientists, our seeing produces fear and paranoia. The answer of the early twentieth- century town planners to cruelty to children, sexual murder and crime in the streets was a perfectly regulated, designed and ordered urban space. That solution in its turn is now perceived to have failed. Like the Victorians, we look into the 'abyss'; like them we see horrors (see Walkowitz 1993). Yet like them too, we, women as well as men, continue to negotiate our urban spaces successfully, and perhaps city living must always be just such a contradictory experience. Only the utopians could imagine a perfect life in a perfect city.

Notes

1 'God made the country, man the town' is one of Cowper's most famous maxims. For an account of his influence on the pre- and early Victorian middle classes see Davidoff and Hall 1987.
2 For a discussion of Howard and others see Fishman 1977.
3 See also Stone 1977.
4 Wolff 1985, 1990. See also Pollock 1988. For a critique of their position see Wilson 1992.
5 For a discussion of Kracauer's *Der detectiv Roman*, 1922–1925 see Frisby 1985.
6 The classic account of the *flâneur* is to be found in Benjamin 1973.
7 A recent market research survey carried out by Mintel showed that 'more than 13 million people living in cities yearn for a more tranquil existence in a small town or in the countryside'. This survey found that the desire for a rural existence was strongest in the 15–34 age group. This trend has been apparent since the 1970s, and for the past twenty years the 'fastest growing districts were generally the more rural parts of the country', while urban areas have steadily lost population. See Ward 1992.
8 See Moore 1991.

Bibliography

Ariès, Philippe (1973) *Centuries of Childhood*, Harmondsworth, Penguin.

Bellamy, Edward (1888) *Looking Backward: 2000–1887*, reprinted Harmondsworth, Penguin, 1982.

Benjamin, Walter (1973) *Charles Baudelaire: A Lyric Poet in the Era of High Capitalism*, London, New Left Books.

Chandler, Raymond (1943) *The High Window*, reprinted London, Pan Books, 1979.

Clark, T. J. (1985) *The Painting of Modern Life: Paris in the Art of Manet and His Followers*, London, Thames and Hudson.

Davidoff, Leonore and Hall, Catherine (1987) *Family Fortunes: Men and Women of the English Middle Class 1780–1850*, London, Hutchinson.

Davis, Mike (1990) *City of Quartz: Excavating the Future in Los Angeles*, London, Verso.

Fishman, Robert (1977) *Urban Utopias in the Twentieth Century: Ebeneezer Howard, Frank Lloyd Wright and Le Corbusier*, New York, Basic Books.

Frisby, David (1985) *Fragments of Modernity: Theories of Modernity in the work of Simmel, Kracauer and Benjamin*, Oxford, Polity Press.

Grafton, Sue (1991) *H is for Homicide*, London, Pan Books.

Hayden, Dolores (1981) *The Grand Domestic Revolution: A History of Feminist Designs for American Homes, Neighbourhoods and Cities*, Cambridge, Massachusetts, MIT Press.

Hoggart, Richard (1957) *The Uses of Literacy*, Harmondsworth, Penguin.

Howard, Ebenezer (1898) *Tomorrow: A Peaceful Path to Real Reform*, reprinted as *Garden Cities of Tomorrow*, London, Faber and Faber.

Huyssen, Andreas (1986) 'Mass culture as woman: modernism's Other', in *After the Great Divide: Modernism, Mass Culture, Postmodernism*, London, Macmillan.

Jacobs, Jane (1961) *The Death and Life of Great American Cities*, Harmondsworth, Penguin.

James, Henry (1907) *The American Scene*, reprinted London, Rupert Davis, 1968.

Jameson, Fredric (1984) 'Postmodernism, or the cultural logic of late capitalism', *New Left Review*: 146.

Jay, Martin (1986) 'In the empire of the gaze: Foucault and the denigration of vision in twentieth century French thought', in David Couzens Hoy (ed.), *Foucault: A Critical Reader*, Oxford, Basil Blackwell.

Joyce, James (1922) *Ulysses*, reprinted Harmondsworth, Penguin, 1986.

Kracauer, Siegfried (1937) *Jacques Offenbach and the Paris of His Time*, London, Constable.

Mauclair, Camille (1982) 'Le Nouveau Paris du peuple', and 'Le Style de la rue moderne', in Rosalind Williams, *Dream Worlds: Mass Consumption in Late Nineteenth Century France*, Berkeley, University of California Press.

Miller, Michael (1981) *The Bon Marche: Bourgeois Culture and the Department Store 1869-1920*, London, Allen and Unwin.

Moore, Suzanne (1991) 'Killjoy culture', in *Looking for Trouble: On Shopping Gender and the Cinema*, London, Serpent's Tail.

Moretti, Franco (1983) 'Homo palpitans: Balzac's novels and urban personality', in *Signs Taken for Wonders: Essays in Sociology of Literary Forms*, London, Verso.

Mulvey, Laura (1975) 'Visual pleasure and narrative cinema', *Screen*: 16, 3.

Poe, Edgar Allen (1984) *Selected Writings*, Harmondsworth, Penguin.

Pollock, Griselda (1988) 'Modernity and the spaces of femininity', in *Vision and Difference: Femininity, Feminism and the Histories of Art*, London, Routledge.

Simmel, Georg (1950) 'The metropolis and mental life', in Kurt H. Wolff (ed.), *The Sociology of Georg Simmel*, New York, The Free Press.

Townsend, Peter (1957) *The Family Life of Old People*, London, Routledge and Kegan Paul.

Walkowitz, Judith R. (1993) *City of Dreadful Delight: Narratives of Sexual Danger in Late Victorian London*, London, Virago.

Ward, Stephen (1992) 'Dissatisfied city dwellers ream of rural "good life", ' the *Independent*, 2 November.

Wharton, Edith (1905) *The House of Mirth*, reprinted London, Oxford University Press, 1952.

Wilson, Elizabeth (1991) *The Sphinx in the City: Urban Life, the Control of Disorder and Women*, London, Virago and Berkeley, University of California Press.

Wilson, Elizabeth (1992) 'The invisible *flâneur*', *New Left Review*: 191.

Wolff, Janet (1985) 'The invisible *flâneuse*: women and the literature of modernity', *Theory Culture and Society*, 2: 2, special issue 'The fate of modernity'.

Wolff, Janet (1990) 'Feminism and modernism', in Janet Wolff, *Feminine Sentences: Essays on Women and Culture*, Cambridge, Cambridge University Press.

Young, Michael and Willmott, Peter (1952) *Family and Kinship in East London*, Routledge and Kegan Paul.

Wendy McMurdo

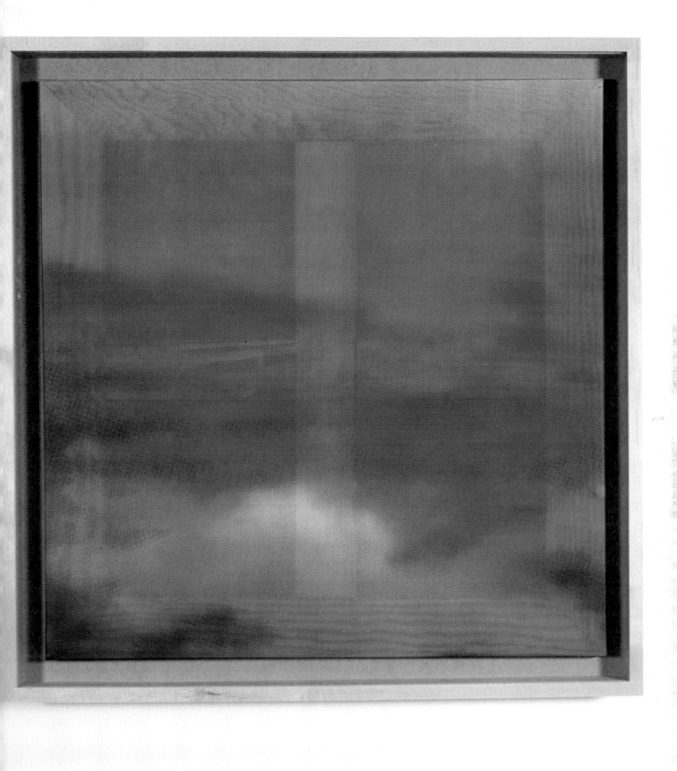

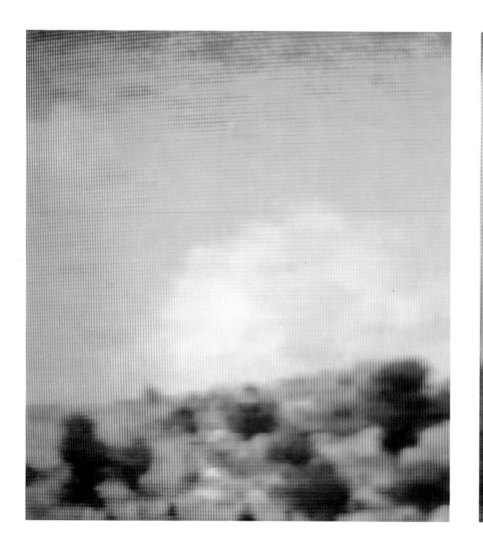

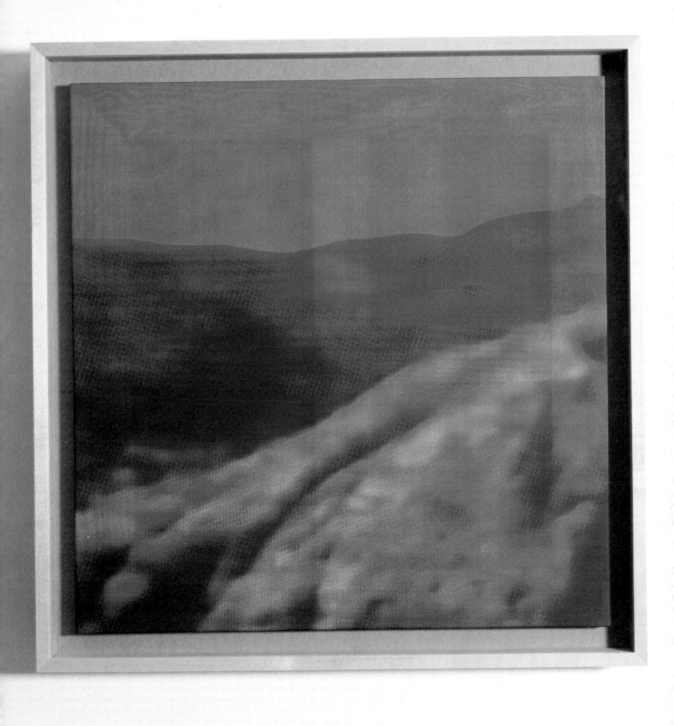

Telling times:
Tales of photography and other stories

Yve Lomax

TELLING TIMES experiments with the idea that critical theory is a 'narrative' like any other. Rather than maintaining an opposition between theoretical discourse and narrative – or science and myth – this text plays with the idea that theory and 'telling tales' are inextricably bound up with each other. Starting with the 'myth' of the photographic image as a frozen moment, *Telling times* seeks to explore the question of difference in relation to time. 'What conception of time has imposed itself as the one and only time, the correct time, by subordinating and negating other times?'

By way of an introduction

When the fragrance of a body beckons we may ask, 'well then, what is a body? ...'

A body can be anything – an animal, an idea, a body of sounds, a mountain, a linguistic corpus, a child, a photographic body of images or a wind. A body, we might say, is never separable from its relations with the world.

It is the effects that bodies have upon one another which come to constitute the photographic image or indeed make the child. It is the relations entered into which come to define a body. 'Nothing but relations', we may reply.

Here then are bodies which are not defined or distinguished in terms of an internal essence, which conditions or gives birth to the mode of their being. 'The interior is only a selected exterior, and the exterior a projected interior' (Deleuze 1988: 125). Here the inside and the outside are continually turning inside out.

Bodies are continually affecting each other and in so doing, composing, recomposing and decomposing a variety of relations. As such, we might say that a body partakes of differing times. In old age we can enter into relations which make us very young. However, have our Western bodies, both 'publicly' and 'privately', become so accustomed to following a single linear time that to intuit a multitemporality seems a little difficult? Yet as our bodies enter into different relations and changing contexts, perhaps it is not so difficult to accept that a body is of *all times*.

And here the words of Michel Serres, philosopher of science, come to mind: 'The living organism...is of all times. This does not at all mean that it is eternal, but rather that it is an original complex, woven out of all the different times that our intellect subjects to analysis or that our habits distinguish or that our spatial environment tolerates... All the temporal vectors possessing a directional arrow are here, in this place, arranged in the shape of a star. What is an organism? A sheaf of times. What is a living system? A bouquet of times' (Serres 1983: 75).

In *Camera Lucida* Roland Barthes speaks of the photograph's immobilisation of time. 'A strange stasis', he says, 'the stasis of an arrest.' (Barthes 1981: 91) It is not only Barthes who speaks of the photograph as an arrest of time. How often have you heard the idea that the photograph immobilises time?
- 'The photograph is a device for stopping time.'
- 'The photograph is a frozen moment.'
- 'The photograph captures time.'
- 'The photograph freezes time.'
- It seems to me that we have become fixed upon fixing the photograph as a segment of frozen time.

Let us for a moment call to mind that infamous idea of the photograph as a window on the world. Now, when time enters the picture it seems no mere fluke that the image of a window can easily be seen as a sheet of ice. Here we have two images which can be placed over one another without radically altering the picture: we have an image of a fluid that has become a solid and which has, to a greater or lesser degree, transparency.

The idea that the photograph is a segment of immobilised time seems to exhibit all the signs of an *idée fixe*.

@

An *idée fixe* is by definition an idea which has become fixed, immovable; by definition there is no movement or warmth towards other ideas. There is no thinking that things could be otherwise. A solid prejudice rules: we shall not be moved into thinking something other.

An *idée fixe* is not predisposed towards mobility: immobilisation is what it

39

favours. It favours freezing rather than fluidity. A fixed idea is not prepared to open itself to the turmoil and turbulence of fluidity: it prefers a frozen heart to an open heart.

When ice is below to such a degree, to touch is to have one's fingers burnt. Yet there is another degree, considerably higher, where to touch is to melt. We may well ask then: what sort of touch does it take to melt the heart of an *idée fixe*? What sort of touch makes a fixed idea warm to other ideas? I don't have an exact idea of what the requisite touch would be; like a love that comes upon one when we least expect it, perhaps it is all a matter of being taken by surprise. Has it not always been by surprise, that unexpected touch, that philosophy has melted my thoughts and set other ideas in motion?

I am suspicious of those (including myself) who proudly claim that they are free from prejudices. Yes, I carry my little bundle of fixed ideas. Yet having carried this bundle over the years, it is interesting to note how the contents have changed. I have stubbornly fixed upon one idea and then at another moment, quite unexpectedly, found myself monomaniacally arguing for another. And the seeming paradox which now confronts me is that I am fixed upon questioning the idea that the photograph immobilises time. Yet this paradox brings into play something that I have wanted to do for some time: to explore the fragrance of different times.

'Well,' someone may ask, 'how can you be sure that we have become fixed upon the idea of the photograph as an immobilisation of time? Do you believe that this idea has become *doxa*, received opinion?'

'I am not sure if this idea can be said to be received opinion. I haven't done an opinion poll. I have no idea.'

But I do have an idea.

I have a hunch. The idea of the photograph as an immobilisation of time, whether or not it is identified as 'frozen' or 'received opinion' , has given me an idea to explore. This idea started with the writing of *Sometime(s)* (Lomax, forthcoming). I say started, but it was more a case of unexpectedly finding myself in the middle of considering some times in relation to the photographic image. I hadn't started out with the precise idea to write upon 'Photography and Time'. If I had started with such a grand title then I would never have put pen to paper, out of sheer fear. It was a matter of being taken by surprise. Once again I had been browsing through *Mille Plateaux* (Deleuze and Guattari 1988) when suddenly I fixed upon the words 'sometimes,

sometimes, sometimes'. I had been considering the idea that any single photographic image has the potential to produce a diversity of effects, that more than one story/time can be told. Sometimes a laughter effect. Sometimes an economic story...

Suddenly my ideas were away.

I began thinking that with any still photographic image there isn't just one time, on the contrary there is a plurality of times, not all of which are happy to consort with each other. The picture was becoming more turbulent than I had expected. Different cultural times. Different social practices of time. Different models and images were competing with each other. Circles. Lines. Spirals. Jewish time. Christian time. Islamic time. Capitalism's time. Animal times. Clock-wise time. Asking 'what is time?' suddenly took a different slant. What conception of time has imposed itself as the one and only time, the correct time, by subordinating and negating other times?

@

When time is said to have been stopped, I start thinking that time moves. When ice is said to have formed, the image of water begins to flow...

It seems to me that by way of immobilisation all is set in motion for a certain conception of time to fill up the picture. Indeed, it seems to me that the idea of the photograph immobilising or freezing time sets in motion the very idea that time, by its own nature, flows.

To fix upon the idea that the photograph immobilises time is to endorse, perhaps unwittingly, a certain conception of time. Perhaps we should take care to turn the photograph over and see if such an endorsement has not permitted a certain conception of time to be written as *the* time, the definite article itself.

@

Questioning the idea that the photograph immobilises time, and equally concerned to ask if one conception of time imposes itself as the only one, I began to consider the idea that time *flows*.

Suddenly I heard the sound of running water and in the blink of an eye the image of a river began to flow. I began to listen, as attentively as I could, to the conceptions of time that the flowing river set in motion. Often coming in brief

snatches, I heard various stories. I couldn't be sure that I had heard the stories correctly, or heard them all, yet I began nonetheless to formulate my own theories. As I put my theories together it seemed no accident that, in time, a linear story began to impose itself. Oh yes, the stories had gone around in circles but as I put my theories together, incomplete as they were, I soon realised that what I had been hearing added up to a particularly and perhaps exclusively Western *line*.

Time itself does flow, as a river flows past a bank-side observer.
 Now this is an image which forms the idea that time flows all by itself, that it has self-existence, that it is absolute:
 – For the Ancient Greeks there was in the beginning Oceanos, a divine river. This god of a river flowed around the rim of the world in a forever recurring circle. Oceanos had all the time in the world; the river flowed absolutely and eternally. Indeed, there was no time that did not belong to Oceanos; from this cosmic river flowed the 'generation of all'.
 – Now the divine river of Oceanos repeated itself in the figure of Chronos, 'the round element'. With Chronos time repeated its never-ending cycle. The circular image of time continued to flow on eternally, as it does still today on those circular clock faces which adorn walls and wrists and all sorts of mantelpieces. However, a difference emerged when the figure of Chronos merged with Kronos.
 – With Chronos/Kronos time took a definite direction. The flow remained absolute and independent of any observer who happened to sit upon the bank side, but now it became irreversible. Unlike the cosmic river which remained forever high in the sky, this river came down to earth. There was only one way to go, only one way to flow. There was no question of time repeating itself. Time was to proceed along a one-directional line and mortals came to speak of *chrono-logical* time.
 – Known as 'the giver of measures', Chronos/Kronos supplied the idea that time could be measured by marking the river's flow. Walking along the river bank, mortals were given the idea of *passages* and *lengths* of time. Indeed, it could be said that Chronos/Kronos bestowed upon mortals the idea of a strip or line along which lengths could be marked off and numbers affixed.
 – With the image of the river in sight, the bank-side observer was given the notion that time could be measured by the flow of a substance. And so time-measuring instruments were devised which were based upon the flows of water, mercury or sand.

The idea of *measurable time* flowed and mortals developed a passion, if not obsession, for perfecting those instruments that came to be known as clocks. In remembrance of the eternal time of Oceanos their faces may have been round, yet the development of clocks proceeded with a very definite, linear conception of time. Clocks imposed their conception of time and under their influence some mortals came to believe that clockwise time was the only time to tell.

– Time pursued an irreversible course and, influenced by the figure of Kronos, mortals became consumed by the idea of time as the great devourer. Kronos was a deadly figure, he ate his own children and reminded mortals of their mortality. With Kronos time took a negative turn; it became a monstrous consumer. In the end all is lost to time, all is eaten up and destroyed. Coming face to face with Kronos one could not avoid meeting death. Here was the face of the grim reaper, the figure who with sickle in hand 'harvests' all.

– Kronos brought his image to bear upon the idea that time pursues an irreversible line, yet following this line mortals began wishing that they could immobilise time and win for themselves immortality and everlasting life.

– Adam and Eve ate apples and Kronos ate his offspring; in both instances there was a Fall from the paradise of heavenly eternal time. However, a great redeemer was to be born who would save mortals from the greed of an all-devouring time.

– A son was born in Bethlehem, his name was Jesus. But this was no ordinary son; this was the son of a god who had a redeeming plan. In terms of this god's plan, time was still to pursue a linear course yet now there was a *telos*: linear history was to flow purposefully towards a meaningful end. Mortals will progress towards perfection and finally they will be delivered from linear time itself. The river of time will give up its dead and a new heavenly time will be created. In the end time will end and death will be no more.

– Christ was crucified upon the cross, yet upon his remarkable return from death mortals were given the promise of eternal light and everlasting life.

– The river of time carries me through to Christian historical time. Christianity has taken great trouble to make its historical time the one and only time, the universal story. The year is now 1687 *anno Domini* and for Sir Isaac Newton, who has just published *Principia Mathematica,* the flow of time continues to be absolute and universal. For this famous English scientist time flows, 'equably without relation to anything external'. He who observes time does not affect time and, moreover,

whosoever seeks to measure it shall find time universally the same.

@

The time of a season. The time when changes in the weather make us chat to a stranger. 'It's getting colder, summer is definitely over'. Another time. Autumn time. A turning time. Yet not exactly the same time returning again.

The colour green turns to rusty brown. A vibrant wind takes a turn with fallen leaves and a swirling dance proceeds. Pages of a book are turned and I read a popularised account of Albert Einstein's Theories of Special and General Relativity.

Leaves and wind and relativity.

I listen to stories of how the Theories of Relativity had stirred up the conception of time as flowing universally the same. I hear that these theories had whirlwind effects upon the Newtonian conception of time. The absolute and universal time which Isaac Newton wished to believe remained independent of space is completely turned around: with the Theories of Relativity both space and motion affect the telling of time.

Leafing through a book. Changes in the weather. Listening to a stranger chatting to me: 'The idea of a universal present is so important that it should be afforded the status of a myth. Deeply ingrained in Western world views had been the concept of time flowing uniformly all over the universe.' (Friedman and Donley 1989).

@

It may well be said that it is a Western myth that time flows the same all over the universe. Yet would we agree that such a myth is purely innocent? I cannot help but ask if this myth, this deeply ingrained conception of time, has not been part of Western culture's drive to universalise itself, to make its world-view the only world-view. To make, that is, its conception of time the one and only time to the detriment of others.

@

In terms of the 'deeply ingrained' Western view of time flowing uniformly all over the universe, I am afforded the belief that I can snap my fingers and the diversity of the

whole universe will share this very instance, this very same moment. Now, not all of the universe may be known to me as it changes from instance to instance, yet this conception of time does allow me to think of all the people and planets and everything else and envisage them doing whatever they may be doing at this moment, i.e. *now*. At this present moment a planet is spinning, a sun is shining, a bee is humming, a bird is flying, whilst a worm is dying and a human is sighing. *Snap*: I may not be able to photograph it all, but the idea of a universal present allows me, for a moment, to envisage the 'universe as a whole'.

But listen, I say to myself, have you not heard that the Theories of Relativity snapped this whole apart? Have you not heard that with these theories the universe as a whole has been separated into fragments that can never share a universal moment of time?

- A planet spinning.
- A bee humming.
- A worm dying.
- A human sighing.
- I think of these lines and the individuality of their times and I ask myself: could it be that the Theories of Relativity took up with the question, *is time one or multiple*?

@

Humpty Dumpty may have taken a great fall, yet amid the clatter of all the king's horses, and all the king's men trying in vain to put the universal whole back together again, perhaps we shall hear chatter of times many and multifarious...

For some time now I have been reading the novels of the French writer Michel Tournier. How long this time has been I couldn't say; it feels like an indefinite time, a time not fixed by limit or line. Here are novels which for me can't be read once and then relegated to the bookshelf to gather dust and yellow. Sometimes it is a single word which beckons me to return to a particular passage; sometimes it is a smart metaphor which quickens me to return and hurry through pages; sometimes it is an astonishing image which having amazed me once, makes me want to look and listen again. For a host of reasons I find myself returning to these novels. They haunt me. They compel me.

On this particular day, a passage towards the end of the novel *Les Meteores*

(translated as *Gemini*) (Tournier 1989a) suddenly came to mind. Perhaps it was the spirit of an autumn wind dancing with the fallen rusty leaves outside my window which had stirred my thoughts. Perhaps it was the question – is time one or multiple? – which had quickened me, inexplicably at that moment, to return to those pages. A vague idea was in the air; its fragrance beckoned me. My thoughts began to dance and once again I found myself following a hunch, the outcome of which I knew not.

In astrology Gemini pertains to a heavenly constellation containing two bright stars – the twins. In Michel Tournier's novel *Gemini* I hear a tale of a twin who, having become 'dispaired' through losing left limbs and twin brother, finds himself – his time – partaking of the varying times and individualities which pertain to the weather...'the wind blows as I breathe, a rainbow spans the heavens in the time it takes my heart to become reconciled to life.' (1989a: 450) Ceasing to possess the 'health' of wholeness, this dispaired twin finds himself drifting, as a nomad, and discovering the multiplicity of meteorological times.

Let me tell you more.

Everyone knows stories about identical twins – one gets a cold in London, the other sneezes in Rome. Twins, we may conjecture, are the very stuff from which myths are made. Fascinated by myth – 'a story that everybody already knows' (Tournier 1989b: 157) – and finding the twin theme an enormously fertile one, Michel Tournier launches us into a tale, a lengthy journey, which from the very first page is much influenced by the weather: 'At 5.19 p.m. a gust of wind from the west-south-west uncovered the petticoat of old Henriette Puysoux, who is picking potatoes in her field...' turned over eight pages of Aristotle's Meteorologica, which Michel Tournier was reading on the beach at Saint-Jacut... 'started the wind pump racing at the Ferme des Mottes; and snatched a handful of gilded leaves off the silver birches in the garden of La Cassine' (Tournier 1989a).

As children the identical twins Jean and Paul are united as one. No one, not even their parents, can tell them apart. They are paired as one: Jean – Paul. Having but one soul for two bodies their beings beat to the same tempo. Both are in tune with each other; at any one moment Jean's time is the same as Paul's time. Jean – Paul live concordantly and simultaneously: their childhood twinkles with 'twinned' time.

As adulthood severs the innocence of childhood, Jean departs from his twin. Jean elusively roams the world, in pursuit follows Paul. Driven by a desire which refuses to discover a world of difference, Paul seeks to restore his twinship to its

original unity, to bring Jean back to the 'one and the same'. Yet this restoration is never to be.

In his quest to be reunited with his twin brother, Paul suffers a terrible injury which results in the amputation of his left limbs. Paul awakens to his dispaired state and his heart breaks with the realisation that his twinship, his wholeness, is no more. Nothing will ever be the same again. Yet even as Paul suffers emotional and physical pain, a hope swells: Paul finds himself moving towards a certain *porosity*. With left limbs missing Paul discovers that his body is open to and permeated by the times of the weather. 'There is sickness still, yes, and great pain. Yet hope swells in my heart as I realise that I am in direct contact, plugged into the skies and to the pattern of the weather. I begin to perceive the birth of a barometric body, a pluviometric, anemometric, hygrometric body. A porous body through which all the winds of heaven breathe' (1989a: 441–2).

Through disablement and confusion of lost left limbs with lost twin, Paul feels himself extending and moving out of his miserable obsession to bring all times under the control of the 'one and the same'. Feeling himself extending, Paul ventures to take up with the life and times of nomadism: 'I know it is this left side of mine which moves, wriggles and pushes out prodigious extensions into my room, into the garden and soon perhaps into the sky and sea. *It is Jean...* Jean the Nomad, Jean the Inveterate Traveller' (1989a: 447).

The more one side of Paul becomes fixed and lives a sedentary life with a matchless intensity, the more, paradoxically, his other side, his left side, feels unhindered to wander and partake of, rather than vainly attempting to control, the time(s) which pertain to the mists, the snows, the frost, the dog-days and the aurora borealis.

Reaching into the sky and sea, Paul's left side moves out of the time controlled by clocks and regularised by straight lines. Times at sea and times in the air. Times that toss about in a roll that no military meteorologist can bring under control, predict and make march, rank and file, to the same incessant tempo.

@

Having become dispaired, having lost not only his same but also his other, Paul finally finds himself re-constituting. As a calm, clear flow of dry freezing wind makes itself

felt, Paul discovers his participation within those multifarious times which, in the French language, constitute all weather – *les temps*.

Let me say just a little more.

In *Gemini* Michel Tournier plays with and upon the twin meanings of the word *temps*. In French, and other languages derived from Latin, time and weather are 'one and the same'. Time and weather are like identical twins. As Jean and Paul suffer a dispairing so do time and weather: both cease to partake of the 'one and the same'. There is a dispairing and the emergence of difference, yet as Paul finds himself extending and re-constituting, a (re)merging occurs between time and weather. This (re)merging is not merely the restoration of an original unity, a return of the same identity, but a re-constitution which brings with it a difference. Whilst time and weather merge time no longer beats to the same tempo. With this re-constituting of the intimate relation between time and weather, *les temps* become as irregular and infinitely varying as the times of the weather. Here then are times which remain uncontrolled by and irreducible to the clock and its predictable, ordered and regularised time.

For Paul the dispaired twin who has lost 'the one and the same', time becomes as unpredictable and unruly as that dynamic non-linear system which we call the weather. In short, the linear conception of time becomes complicated by the non-linear times of the weather. Vortices, pockets of turbulence and perturbations. Clocks splattered with rain. As the science of complexity tells us, non-linear systems are everywhere, in every puff of wind, every swirl of mist, every cloud which dampens the day, every spring that flows gushing from our hearts. Has not love always known of the turbulence of non-linear times?

At last I come to the end of this particular tale.

We end (or is it begin?) with infinitely varying times, a multiplicity of times which partake of the seasonal round but also abound with the individuality, the particularity, of a fog, a frost, a ray of sunshine that falls across and caresses the left cheek of a dispaired twin or a wind that suddenly picks up at 5.19 p.m. and turns over eight pages of a popularised account of Albert Einstein's Theories of Relativity.

Is time one or multiple?

@

The first frost of winter had arrived leaving its sparkling pattern upon ground, grass

and window-pane. As I reflected upon this scene the idea that the photograph freezes time suddenly began to turn. Frost on the window-pane and the photograph as a frozen moment: was I glimpsing here the knowledge that the photograph partakes of times which pertain to the weather? The very idea of the photograph freezing time may be said to be a myth, yet perhaps this myth recognises, if only in a glimpsed manner, that the photograph has potentially as many times as *les temps* of the weather.

It may be a still day without a breath of wind. Stillness may prevail, yet even upon such a day the times of the still photographic image remain unfixed, indefinite.

Well, perhaps it is a myth that time 'itself' flows and an illusion that the photograph freezes this flow. Whilst it may be our delight to dispute myths and illusions, let us not dream that our argument will not bring into play other myths, other illusions. Again I am reminded of the words of Michel Serres. 'Knowledge without illusion is an illusion through and through, in which everything is lost, including knowledge. A theorem of it might be sketched like this: *there is no myth more innocent than that of a knowledge innocent of myth*' (Serres 1985: 91–2).

A cold, clear winter's night and the stars shine bright. The meteorologist predicts a frost and the astrologer observes the heavens at the hour of a birth and predicts the events of a life. Meteorological times and astrological times: as I listen to the weather forecast and read my 'stars', these times form part of my daily times.

I was born on the 18th of December. I was born under the sign of Sagittarius. Here we have the image not only of a fabulous monster, half human and half horse, but also the Archer. In short, a monster who shoots arrows.

My life, horoscopically speaking, partakes of a Sagittarian time. A time which pertains to sagitta – an arrow. Time Sagittaria, time which is arrow-headed. Yes, we come to the image of time as an arrow.

The arrow of time. Come, let us see in which direction this image will take us.

@

A Sagittarian shoots her arrow. As the arrow flies through the air we may *snap* our fingers and ask: At what point now is the arrow's time? However, in order to answer this question and secure the instant snapped, do we not have to convert the arrow's time into line? Take a ruler. Draw a line. Then you can divide infinitely the arrow's

time into a series of points or instants. Yet as we convert the *sagitta's* time into a line are we not confronted with the paradox that perplexed Zeno of Elea many a year ago? If the arrow were at a certain point at every moment then, *snap*, wouldn't the arrow be immobilised at every instant? And then surely it would be immobilised for ever. The *sagitta* would never be airborne. As we convert the arrow's time into a line and make precise points or instants, do we not come to miss *sagitta's* time completely? Something happens, as it were, behind our backs.

@

In the early part of the twentieth century, the philosopher Henri Bergson was led to consider the idea of time; and there, as he said, 'a surprise awaited me'. Henri Bergson met with the idea that the mobility which pertains to time is irreducible to a series of 'instants' or 'points'.

Let me quote at length: 'Ever since my university days I had been aware that duration is measured by the trajectory of a body in motion and that mathematical time is a line; but I had not yet observed that this operation contrasts radically with all other processes of measurement, for it is not carried out on an aspect or an effect representative of what one wished to measure, but on something which excludes it. The line one measures is immobile, time is mobility. The line is made, it is complete; time is what is happening, and more than that, it is what causes everything to happen. The measuring of time never deals with duration as duration; what is counted is only a certain number of extremities of intervals, or *moments*, in short, virtual halts in time' (Bergson 1949: 12).

How can we come to understand Time Sagittaria without 'converting it to a line and then dividing the line into mathematical points in time or instants' (Friedman and Donley 1989: 124).

The terms which designate time are borrowed from the language of space. When we reduce *sagitta's* time to a number of instants or moments we are spatialising time. That the arrow's time should appear, paradoxically, immobilised at every instant is an effect of the spatialisation of time. *The moving arrow never is at a certain point.*

Time and space have been placed on the same level and treated as things of a kind. 'The procedure has been to study space, to determine its nature and function, and then to apply to time the conclusions reached' (Bergson 1949: 14). To pass from

space to time one only has to change one word: replace juxtaposition with succession.

Space and time have become like counterparts. Yes, we could say that they become like identical twins where no difference can be told. Let us cease treating space and time as twins. For, when we do so, it is always space which speaks, always space which seeks to have the last word, always space which seeks to dominate and return the difference to the rule of the One and the Same.

'When we evoke time it is space which answers our call' (Bergson 1949: 14).

It is important, however, to specify what kind of space answers our call when we evoke time. Exactly what space is Henri Bergson referring to when he speaks of the *spatialisation of time*?

The space in question is that of Euclidean geometry.

White lines drawn on blackboards. At school I was taught a geometry of flatness, worked out by a Greek mathematician named Euclid over two thousand years ago. Against the plurality of different spaces and ways of representing space this geometry drew a univocal model of space. For Euclidean geometry there is only *one* space. No other space counts in the way that this geometrical space does. 1. 2. 3. Here is the one space where metric measure can apply its rules. Here is the one space which infinitely can be divided and measured.

Geo-metry. 'The measure of the world.' The spatialisation of time pertains to the space which the measuring rules of Euclidean geometry invented.

Geometrical space = measurable space = homogeneous space. Indeed, we may ask: 'Have the rules of Euclidean geometry led us to believe that all space is the *same*? When a geometrical line is applied to the question of time is it any accident that we should come to maintain the idea of time as succession, and twinned with this, the idea that time is homogeneous, the same throughout?

Let us think of time in terms other than those borrowed from space.

@

When we reduce time to a series of points or instants we are spatialising time. When we speak of immobilisation of time we are spatialising time. And for Henri Bergson the photograph provides the perfect example of such spatialisation of time.

'Immobility is but a picture (in the photographic sense of the word) taken of reality (duration) by our mind' (Bergson 1957–59); '...moments of time...are only

snapshots which our understanding has taken of the continuity of duration' (Bergson 1949: 16).

Let me clarify the picture a little more.

Imagine that we 'shoot' in rapid succession a series of photographic shots of the *sagitta's* flight. We develop the film and from the negatives make a 'contact sheet'. As we look at this sheet we see strips of images. We see a series of distinct segments (frames) immediately adjacent to each other. Succession does become juxtaposition. Photographing *sagitta* appears to reduce the arrow's flight (time) to a number of immobile pictures or segments. But let us remember that for Henri Bergson the mobility which pertains to time is irreducible to immobile states. In short, the photograph never arrests or freezes time. The photograph doesn't immobilise time; it *spatialises* time.

We may come to the conclusion that photography is a spatialising machine *par excellence*. Yet, is this the only way to regard the photographic image? What if we extended to the snapshot, the photographic image, the invitation to think time in terms otherwise than those borrowed from geometrical space?

When we approach a photographic 'body' with a non-homogeneous concept of time who knows where the image of time as an arrow will take us. Perhaps this image, this photographic shot, will carry us not only to heterogeneous time but also to heterogeneous space?

@

It is almost mid-winter, only yesterday did it seem to be early summer. How time flies!

Time flies and a Sagittarian asks herself: at what point in my life am I now? If this Sagittarian were to follow Henri Bergson's argument perhaps she would reply that, like the moving arrow, the time or duration of her life never is at a certain point.

The time and duration of my life is 'forever incomplete, being always a *fait accomplissant* and never a *fait accompli*; in other words, it is a *continuous emergence of novelty* and can never be conceived as a mere rearrangement of permanent and pre-existing units. It never barely *is*; it always becomes' (Bergson, in Friedman and Donley 1989: 124).

The moving arrow never is at a certain point. The time of my life never is, it is *continually becoming*.

Most certainly, a lifetime can be divided into points. Yes, one can always

proceed in this manner. One can always go from point to point and determine from this procedure a succession of distinct segments. Chronology proceeds in this manner, as does often the writing of autobiographies, and the sequences of family snapshot albums.

My life is never at a certain point, and the photographic image is a 'body' which is continually becoming. To speak of points or segments in time is to concede to the language of geometry and to spatialise time. Perhaps, in so doing, we come to miss the time of our lives.

<p style="text-align:center">@</p>

The arrow of time flies, and for this image the flight is irreversible, yet even in so-called old age we are continually becoming; we can enter into relations which make us young, as it were, novel and new.

I had once seen the arrow of time as an inexorable descent into decay and degeneration. Yet tonight a starburst is occurring. Venus is rising and the arrow of time is bursting into a multidirectional image.

Come, let us have the time of our lives.

Bibliography

Barthes, Roland (1981) *Camera Lucida*, New York, Hill and Wang.

Bergson, Henri (1949) *The Creative Mind*, New York, Citadel Press (Philosophical Library).

Bergson, Henri (1957–59) *Ecrits et paroles* (3 vols), ed. R. M. Mosse-Bastide, Paris, Presses Universitaires de France.

Deleuze, Gilles and Felix Guattari (1988) Mille Plateaux

Deleuze, Gilles (1988) *Spinoza: A Practical Philosophy*, San Francisco, City Lights Books.

Friedman, Alan J. and Donley, Carlo C. (1989) *Einstein as Myth and Muse,* Cambridge, Cambridge University Press.

Lomax, Yve (forthcoming) *Sometime(s)*, Manchester, Cornerhouse Publications.

Serres, Michel (1983) 'The origin of language: biology, information theory, and thermodynamics', in *Hermes*, Baltimore, The Johns Hopkins University Press.

Serres, Michel (1985) in Vincent Descombes, *Modern French Philosophy,* Cambridge, Cambridge University Press.

Tournier, Michel (1989a) *Gemini,* London, Minerva.

Tournier, Michel (1989b) *The Wind Spirit: An Autobiography,* London, Collins.

'SITE' WORK

Jane Brettle

'The Freudian notion of fragments does not pre-suppose the breaking of an image, or of a totality, but the dialectical multiplicity of a process'.

'So too, architecture when equated with language can only be read as a series of fragments which make up an architectural reality'.

Bernard Tschumi – Questions of Space

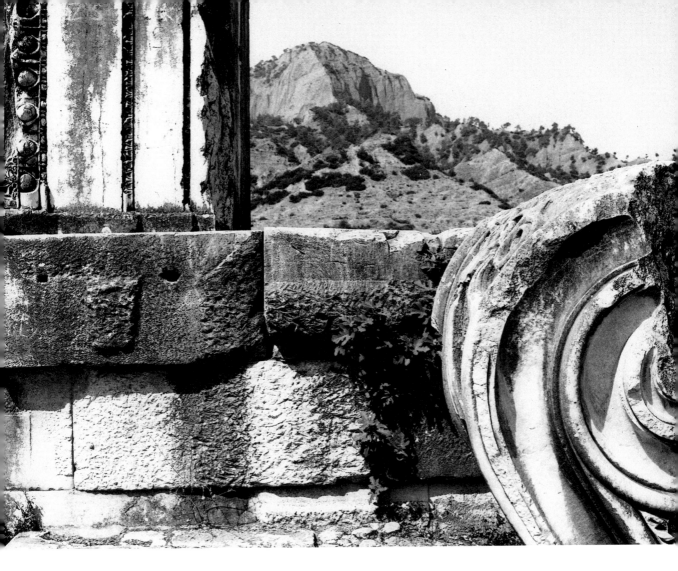

∞

No: 6of15: TpAS

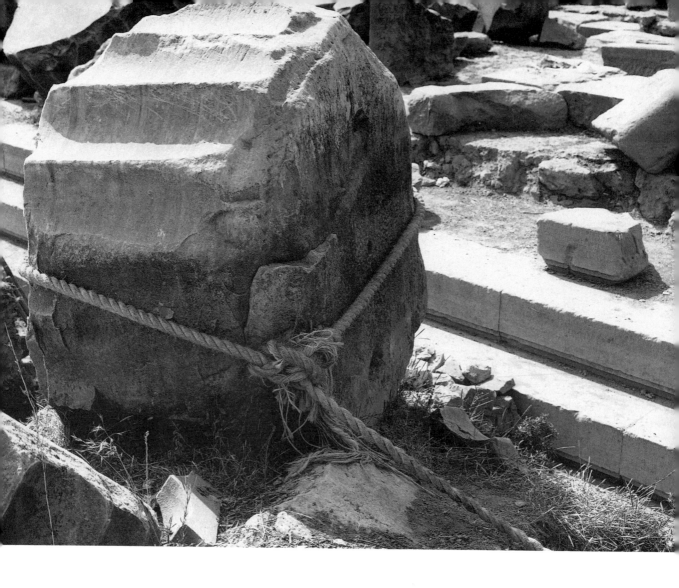

No: 10of15: TpAC

t

No: 3of15: TpAC

F A B R I C

A T I O N

'It is the explosion, the fragmented unconscious, where the architectural 'body' does not reflect the body of the subject, as it did in the Renaissance, but reflects instead the perception of the fragmented body as the built text, a set of fragments of languages and texts, the city...

We will take that built social unconscious of architecture, the city, a text, for it is not the result of the creation of a subject/product of a logocentric, anthropomorphic system. There is no subject there. Here are only fragments of texts and languages to be read, and in this reading they traverse the subject, in the position of reader – writer'.

Diana I. Agrest – Architecture From Without

(dis) LO

(d i s) L O C A T I O N 2

'The future lies like a glittering city, but like the cities of the desert disappear when approached. In certain lights it is easy to see the towers and the domes, even the people going to and fro. We speak of it with longing and with love. The future. But the city is a *fake*. *The future* and the present and the past exist only in our minds, and from a distance *the borders* of each shrink and fade like the borders of *hostile* countries seen from a floating city in the sky. The river runs from one country to another without stopping. And even the most solid of things and the most real, the best loved and the well-known, are only hand shadows on the wall. Empty space and points of light'.

Jeanette Winterson – Sexing the Cherry

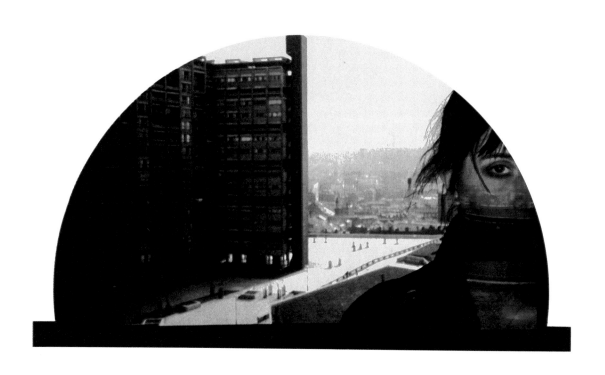

POINT

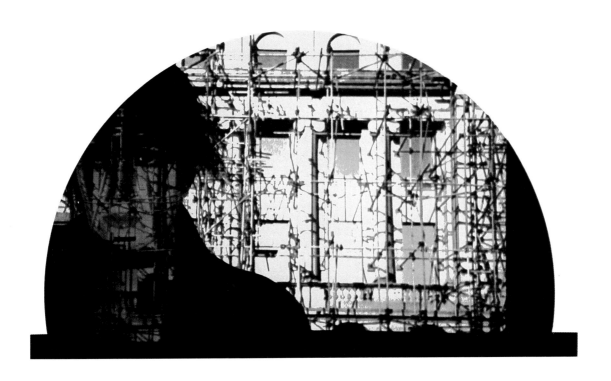

F VIEW

CHRONOSCOPAL
(underexposed, exposed, overexposed)

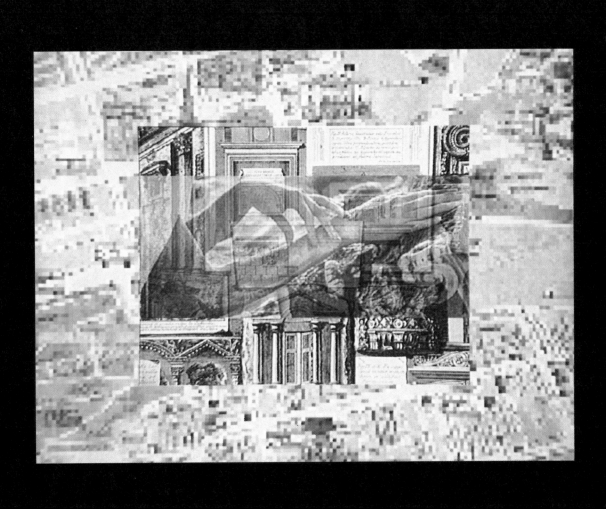

ABOLITION OF DURATION

Gender and the picturesque:
Recording ruins in the landscape of patriarchy

Christine Battersby

WE CANNOT DETECT a particular city in the photographs that Jane Brettle produces. In one image, the beautiful arms of a woman – fetishised and self-embracing in ways familiar to us from glossy advertisements – hold our gaze. It is only slowly that the eighteenth-century drawings of archeological fragments emerge from the middle distance, and from there our eyes move out and we begin to formulate the plan of a city. In reality, the city is Edinburgh, with buildings and contours shaped by Enlightenment dreams of a lost past. That past was both Classical and Gothic; both 'beautiful' and 'sublime' (to use the vocabulary of the time in which it was built). In Edinburgh – 'The Athens of the North' – many eighteenth-century literati allowed themselves to dream of Ossian, that 'primitive' bard who had, supposedly, woven Northern epics as magical as those of Homer.

Although Neoclassicism and Romanticism were once seen as opposed, they are now generally recognised as belonging together. Both tendencies grow out of a nostalgia for an idealised past. In Edinburgh this double longing was written on to the townscape during the fifty or sixty years that started with the construction of the New Town in 1767. The New Town itself is regular, systematic, symmetrical: it pays homage to the lost order of the Roman empire and an idealised Greece. But then comes Calton Hill: a rough and rocky natural feature developed shortly afterwards, but given buildings with Gothic features – irregular, primitive, with battlements. This deliberate roughness and crudeness was designed to pick up Gothic features in the Old Town which was now (for the first time) seen, in contrast with the New, as charmingly 'picturesque'. The old observatory, the two prisons, Nelson's tower were joined in the next few years by newer 'Greek' buildings. Edinburgh's love-affair with the classical past was not dead. Indeed, it existed side by side with the fashion for the Gothic. An attempt was made – using principles drawn from picturesque design – to render Calton Hill the Greek counterpart of the ancient Gothic castle in Edinburgh Old Town. Greek and Gothic dreams could coexist, because what mattered was not the actuality of the past evoked, but the resonances of that past in terms of a picturesque effect.

In this essay I will explore this notion of the 'picturesque' which mediated between the Gothic 'sublime' and Neoclassical ' beauty', and which thus played such a major role in the shaping of Edinburgh. I will look, in particular, at the way gender assumptions were built onto the British landscape via use of this aesthetic vocabulary, and I will use my analysis in order to comment on current debates within feminist aesthetics regarding the possibility of a specifically female gaze and a female sublime. As such, these thoughts have been triggered by Jane Brettle's work, since she is clearly engaged in part with working through some of the same issues. Maps of Edinburgh, appropriated images of buildings and cityscapes, architectural drawings and features of Neoclassical design are all used in her computer-generated and manipulated images. She also photographs fragments of ruins from the classical past: from sites in ancient Greece – subsequently part of the Roman empire, and eventually Turkey – which contain statues or temples dedicated to female deities.

Ruins played a particularly significant role in the tradition of the picturesque, evoking a time and a place *beyond* Modernity. Enthusiasts for the picturesque celebrated that which threatens modern European civilisation – distant lands; distant times; the savagery and disorder of nature; irregular forms of female beauty and power – whilst also, simultaneously, containing all potential disruption via the framing control of the artistic hand and gaze. Brettle's use of ruins is by no means that of the picturesque travellers: her dislocated archeological fragments seem to contest a genre in which remains were recorded primarily in order to enhance the 'picturesque' effect of the overall scene. The representation of ruins does, however, raise difficult questions about how a photographer who is seeking to develop a specifically female viewpoint on the landscape of patriarchy can prevent herself being read as simply merging back into that landscape. Before reaching any conclusions with regard to the nature of a feminist aesthetics, it will, however, first be necessary to examine in some detail the tradition of the picturesque and its gendered schema for imaging nature, buildings and ruins.

For Uvedale Price, whose *Essays on the Picturesque* went through many editions (with supplements on architecture and landscape design) from 1794 onwards, the pleasure in the picturesque involves '*that disposition of objects, which, by a partial and uncertain concealment, excites and nourishes curiosity*' (Price 1810 (v1): 22). For Price, the term picturesque can be 'applied only to objects of sight', and involves a form of pleasurable irritation which is triggered by such qualities as roughness,

incrustation, 'sudden variation', decay, and other forms of irregularity which prevent monotony (Price 1810 (v1): 50–2, 74, 87). Prefiguring what Freud might have said about the origins and pleasures of visual curiosity, Price himself provides strong hints as to the links between the pleasures of picturesque buildings and landscapes and male responses to the female body (Price 1810 (v1): 50–2, 74, 87).

For Price, a degree of picturesqueness makes female beauty 'more amusing, more varied, more playful, but also, "Less winning soft, less amiably mild"' (Price 1810 (v1): 89). However, because the picturesque occupies a precarious position between a beauty that is too perfect to stimulate mental play and a body that is deformed or ruined, an excess of this quality will block sexual desire:

> I have read, indeed, in some fairy tale, of a country, where age and wrinkles were loved and caressed, and youth and freshness neglected; but in real life, I fancy, the most picturesque old woman, however her admirer might ogle her on that account, is perfectly safe from his caresses (Price 1810(vi): 71n). To accord with male sexual desire, the picturesque beauty must look ruinable – not actually ruined. She must seduce the male observer into pursuit, and offer him potential caresses; but if her 'soft and smooth' skin does not invite a mental touch, the 'irritation or stimulus' which is necessary to the visual enticement will be destroyed. It is 'freshness' of female face, form and skin that is needed to mitigate the roughness and irregularity of the picturesque. Otherwise, the 'hard and dry appearance' will block mental curiosity (Price 1810 (v1): 91–2, 125, 80).

Price spends a good few chapters of his *Essays* elaborating on the links between the more general pleasures of the picturesque and sexual preferences (in males). But the full title of his work shows that his main intention was to compare the picturesque *with the sublime and the beautiful, for the purpose of improving real landscape.* Before Price, 'picturesque' had been a term applied mainly to existing landscape, and was much employed in the guidebooks written – and illustrated – by those touring round Britain in order to train the eye of others following in their footsteps. Ruins were much discussed in these guidebooks; but they hardly counted as man-made objects at all. As William Gilpin, one of the most celebrated of these travelling artist-authors, put it, 'A ruin is a sacred thing. Rooted for ages in the soil, assimilated to it; we consider it rather as a work of nature than of art'.[1] It was only after Price that we

find architects such as John Claudius Loudon designing Gothic-inspired houses 'calculated for being decorated with Ivy and Creepers', and noting in 1806 that this 'would have a singular and very picturesque or perhaps romantic effect'.[2] Such 'Gothic' houses joined the fake ruins and follies that had also been constructed for picturesque ends.

To produce a deliberately picturesque effect in 'real' landscape or buildings, what was needed was tight visual control of those aspects of nature which seem most resistant to the gaze. As Price himself put it:

> Infinity is one of the most efficient causes of the sublime...to give [an object] picturesqueness, you must destroy that cause of its sublimity; for it is on the shape and disposition of its boundaries, that the picturesque must in great measure depend (Price 1810 (v1): 84).

To gain this visual control and 'see' the picturesque it was customary to view nature through 'Claude glasses' or a camera obscura. Although unable to fix an image on to paper, these 'machines for drawing' were direct precursors of the modern camera. Indeed, the psychological 'distance' that is often supposed to be a necessary feature of aesthetic experience is historically grounded in the practice of these enthusiasts for the picturesque who carried a miniature camera obscura in their pockets and interposed glass between eye and object, in order to 'see' nature 'like a picture'.

A giant camera obscura still exists, significantly sited in Edinburgh Old Town. It was built on top of an optician's shop as the fashion for the picturesque gained sway. But not every camera obscura was of similar construction: there were some with reversing mirrors, and others incorporating different arrangements of ground-glass lenses. All, however, yielded a two-dimensional image on a flat ground (supposed equivalent to the retina) from which linear tracings, tonal drawings or paintings were produced. The resulting chiaroscuro effect was usefully described by a mid-eighteenth-century drawing instructor who argued against the common assumption that it is indeed reality itself that is captured via the reflections of the camera obscura:

> This glass interposed between objects and their representation on the paper intercepts the rays of the reflected light which render shadows visible and pleasantly coloured, thus shadows are rendered darker by it

than they would be naturally. Local colours of objects being condensed in a smaller space and losing little of their strength seem stronger and brighter in colour. The effect is indeed heightened but it is false.[3]

Thus the 'real' landscape that Price sought to improve by the application of picturesque principles was itself the product of a tension between man (the perceiver and shaper of his surroundings) and a nature which was eulogised, but which was also rendered harmless by having its boundaries and shadows both emphasised and rendered 'pleasantly coloured' and contained. In seeking to mimic this effect, the designer of the picturesque landscape sought to position himself as an omnipresent god: everywhere present, but also hidden in the very light and shadows, as well as in the apparently free-flowing and natural shapes he created. The gaze of the observer was directed by the construction of artificial lakes, the planting of woods, the erection of strategic ruins and the like. Thus, although the resulting vistas were described in language and metaphors that evoked Mother Nature, the apparent roughness, wildness and irregularity was a product of a careful calculation of visual horizons, perspectives and frames. It was a specularised nature – and femininity – that the enthusiasts for the picturesque so admired.[4]

And it is this that makes the picturesque so different from the contemporary aesthetic category of the sublime. This is a category made famous by the writings of Edmund Burke, who presented the opposition between the beautiful and the sublime in language and metaphors that were also strikingly gendered. As Burke put it in *A Philosophical Enquiry into the Origin of our Ideas of the Beautiful and Sublime*:

> There is a wide difference between admiration and love. The sublime, which is the cause of the former, always dwells on great objects, and terrible; the latter on small ones, and pleasing; we submit to what we admire, but we love what submits to us; in one case we are forced, in the other we are flattered into compliance. In short, the ideas of the sublime and the beautiful stand on foundations so different, that it is hard, I had almost said impossible, to think of reconciling them in the same subject, without considerably lessening the effect of the one or the other upon the passions (Burke 1757: 113–14).

According to Burke, it was the beautiful that operates on the (male) observer by a form of flattery; the sublime that threatens to overwhelm his ego via a form of

mental rape. Refusing to see an intermediate category of playful and wilful seduction (the picturesque), Burke believed that he had exhaustively defined the terrain of aesthetic pleasure. However, for Burke the beautiful and the sublime were not only forms of mental response, they were also effects produced by particular qualities in objects. And it was this aspect of Burke's system that triggered later writers to modify his principles in order to make room for the intermediate category of the picturesque.

Burke characterised beauty as a mental state of relaxation produced by the physical encounter with objects that are small, smooth, without sharp contrasts or angles, and with delicacy of form and colour. It is what 'we men' (males) love in 'the sex' (women): this mixed passion which we call love, is the *beauty* of the sex. Men are carried to the sex in general, as it is the sex, and by the common law of nature; but they are attached to particulars by personal *beauty* (Burke 1759: 113–14).

The sublime, by contrast, was bound up with a 'stretching' of the nerve fibres: with tension and with feelings of terror and infinity generated by power, obscurity, magnitude, difficulty, absences (such as solitude, silence and darkness) and impressions of endlessness. Such impressions could be artificially produced by careful manipulation of the elements of the sublime, such as uniformity and succession. Thus, Burke claimed, a Greek temple was more sublime than a cruciform church, since there was no point from which the whole of the Greek temple could be seen. Nor was there an excess of angles that could detract from the immensity of the whole (Burke 1757: 75–6).

Burke's *Enquiry* exerted a prodigious influence on landscape design and architecture. Later writers, however, frequently used Burkean principles to reach contrary conclusions about the relative sublimity of the Classical and the Gothic. As contemporary taste veered away from Neoclassicism, later writers were more likely to adopt the view that the gloom, obscurity and angularity of a Gothic church allied it more nearly with the sublime than with the category of the beautiful. In the 1798 edition of his *Essays on the Picturesque*, Uvedale Price used the term 'picturesque' to dispose of the architectural problems posed by Burke's categorisation. For Price,

> Gothic architecture is generally considered as more picturesque, though less beautiful than the Grecian'. Furthermore, although 'A temple or palace of Grecian architecture in its perfect entire state, and with its surface and colour smooth and even, either in painting or reality is

beautiful; in ruin it is picturesque (Price 1810 (v1): 51–2).

Price, time will produce irregularities on the features of the beautiful which will render it picturesque. This alteration is detected on the beautiful (and hence feminine) features of a Greek temple, or on the wrinkling face of a beautiful woman. Price employs Burkean premises for non-Burkean ends: his category of the picturesque functions as an idealised form of imperfect (irregular or spoilt) feminine beauty.

The difficulty in fitting the Classical and the Grecian on to the Burkean frame was due, at least in part, to the fact that for the Greeks the ideals of beauty were modelled on the well-formed, well-exercised male body; not the delicate, smooth and gentle body of the civilised European lady that Burke took as his ideal. Burke's notion of beauty seems inappropriate for Greek and Roman architecture, since his language reflects the new gender roles in Western Europe, in which 'civilised' woman was denied her ancient alliances with the wild and threatening aspects of nature. During this period the idealised male body and character became more emphatically forceful, godlike, sublime; but the powerful or heroic woman could fit with neither the new ideals of the beautiful nor the sublime.[5]

Since the picturesque functioned as a middle term, somewhere between 'feminine' beauty and the 'masculine' sublime, 'picturesque' became a useful term with which to negotiate gender liminality – both as regards architectural styles, and as regards female power. In this respect, Price seems to have built on a pre-existent usage. Early in the century – indeed, not long after the word was first introduced into the English language – Sir Richard Steele's *The Tender Husband* included the following exchange:

> NIECE: I would be drawn like the Amazon Thalestris, with a Spear in my hand, and an Helmet on a Table before me
>
> CLERIMONT: Madam there shall be Cupid setting away your Helmet, to shew that Love should have a part in all gallant Actions.
>
> NIECE: That Circumstance may be very Picturesque.[6]

The woman here wishes to be drawn in a sublime pose: as a terrible, powerful Amazon. Her male interlocutor obviously sees this as inappropriate to her as a female, and insists that the image be softened by the traditional iconography of love. The

niece's ambitions to be more than merely beautiful are acknowledged; but rendered non-threatening. Steele (always a moralising writer) suggests that male gallantry can be used to make a woman satisfied with the image of herself as 'picturesque', and deflect her from the more threatening sublime.

In aesthetic discourse, 'sublime' was the word used to describe the greatest works of original genius. As such, it was generally claimed that women were unable to produce the sublime. Indeed, authors such as Rousseau and Kant denied women even the ability to respond to and appreciate the sublime.[7] However, although the eighteenth-century writers positioned the ideal woman within the realm of the beautiful, sublimity itself was often given a feminine gender:

> O lead me, Queen Sublime, to solemn glooms
> Congenial with my soul; to cheerless shades,
> To ruin'd seats, to twilight cells and bowers,
> Beneath yon ruin'd abbeys moss grown piles
> Oft let me sit at twilight hour of eve,
> When through some western window the pale moon
> Pours her long-levelled rule of streaming light.[8]

Here sublimity is that absence and infinity that forever recedes from the male spectator of nature and creator of art and aids his genius. The poet in this passage from Thomas Warton's *Pleasures of Melancholy* is a male led into the privileged state of melancholy by Queen Sublime and the feminine moon. As such, Warton fits into a tradition of gendering madness that reaches back at least as far as the Renaissance. Aristotle's authority was used to argue that males of superior genius could benefit from melancholy and produce great artworks, while the minds of inferior types (and women) were simply clouded by the vapours of melancholy.[9] Here again, during the eighteenth century, the term 'picturesque' was used to accommodate female activity in the arts – the writing of 'Gothic' novels and ghost stories; the drawing and painting of watercolour scenes from nature – which could not be aligned with acceptable behaviour for the 'proper' lady, but which also could not be deemed 'sublime' products of art.

As it came to be used in the theory of painting, architecture and landscape design, 'picturesque' had a double meaning in English. On the one hand, William Gilpin devised the category 'Picturesque Beauty' precisely in order to register that

many scenes that were beautiful in Burke's sense did not lend themselves to being painted. Thus, he defined the picturesque simply as '*such objects, as are proper subjects for painting*' (Gilpin 1794: 36). On the other hand, the picturesque came to stand for a certain set of qualities intermediate between the sublime and the beautiful. Since the picturesque was bound up with visual enticement and concealment, a dim light was better than brightness for appreciating the roughness and irregularity of the picturesque scene; whilst overgrown ruins – preferably set off by autumnal shades and textures – were the ideal subject-matter. Gilpin recommended replicating these colours in sketches by subsequently tinting the drawing-paper with a 'reddish or yellowish tinge' to counteract 'the rawness of black and white'.

Not all ruins were automatically picturesque. Price indicated (somewhat contradictorily) that when a building is first destroyed it is simply 'deformed'; it is only as it becomes overgrown with vegetation – and hence becomes assimilated into nature – that it is rendered picturesque (Price 1810 (v1): 199). William Gilpin also imposed limits on the disorder and irregularity of ruins, in order to align them with his picturesque gaze. Thus, on the one hand, he enthuses about the ivy, mosses and lichens covering the ruins of Tintern Abbey: 'all together, they give those full-blown tints, which add the richest finishing to a ruin' and superadd 'the ornaments of time' to the beauty of the architecture (Gilpin 1782: 33–4). On the other hand, Gilpin sounds quite peevish about the failure of the abbey to live up to his ideal of picturesque beauty:

Though the parts are beautiful, the whole is ill-shaped. No ruins of the tower are left, which might give form, and contrast to the walls, and buttresses, and other inferior parts. Instead of this, a number of gable-ends hurt the eye with their regularity; and disgust it by the vulgarity of their shape. A mallet judiciously used (but who durst use it?) might be of service in fracturing some of them (Gilpin 1782: 32–3).

Gilpin's accounts of his travels around Britain, which continued through the 1780s and 1790s, were perhaps more influential than any other works in establishing the fashion for 'picturesque beauty'. But his texts seem already to contain within them the *reductio ad absurdum* of his position: pointing forward to Thomas Love Peacock's rumbustious farce, *Headlong Hall* (1816). It is not a mallet, but gunpowder which Peacock's characters use (in)judiciously, in order to correct the lines of a 'ruined tower on a projecting point of rock almost totally overgrown with ivy' a tower on which

Coleridge (Mr Panscope) is standing, admiring the landscape of the picturesque (Peacock 1816: 61).

Jane Austen's *Mansfield Park* (1814) and *Northanger Abbey* (1818) offer a rather more gentle critique of the fashion for picturesque landscape. And in *Sense and Sensibility* (1811) Austen both utilises and mocks the contemporary alignments between forms of beauty and sexual allure. In this novel the two sisters, Elinor and Marianne Dashwood, represent two different logics of aesthetic taste: that of the Burkean beauty and the picturesque beauty. Elinor (representative of sense) admires – and is admired by – Edward, a man who likes 'a fine prospect, but not on picturesque principles'. He dislikes 'crooked, twisted, blasted trees...ruined tattered cottages...nettles, or thistles, or heath blossoms'; and a 'troop of tidy, happy villagers' pleases him 'better than the finest banditti in the world' (Austen 1811: 80).

Edward claims 'no knowledge in the picturesque'; but he knows enough about it to provide a systematic rejection of its vocabulary and values. Elinor, his love object, has 'a delicate complexion, regular features, and a remarkably pretty figure' (Austen 1811: 40). She thus corresponds to Burke's (rather insipid) recipe for feminine beauty. By contrast, Marianne (representative of sensibility) has a face and figure which departs from Burkean ideals: 'her form, though not so correct as her sister's, in having the advantage of height, was more striking' (Austen 1811: 40). With her brown, transparent skin, her brilliant complexion, her lively, spirited and eager eyes, Marianne exemplifies Uvedale Price's ideal combination of 'freshness' and picturesque beauty. As if to emphasise this point, throughout the novel Austen characterises Marianne in terms of her taste for the picturesque. That taste is also etched on her face and body.

Jane Austen's alignment of the sisters with the competing ideals of beauty is handled with light irony. Marianne is the heroine of the novel, but also subtly critiqued; both via Elinor, and by a paragraph in the final chapter in which she is allowed to outgrow her juvenile and over-romantic preferences. This dimension of the story is handled with such subtlety that a modern reader might entirely overlook it; but it would be hard for her to miss Uvedale Price's heavy-handed attempts to link the taste for the picturesque with female beauty. The men in the 'Dialogue' appended to the 1801 edition of his *Essays* walk past an old rectory, with irregular roofs and rough-cast walls, covered in creepers and blossoms.

'I think,' said Mr Seymour...'that there is a sort of resemblance between the good old parson's daughter and his house: she is upright, indeed, and

so are the walls, but her features have a little of the same irregularity, and her eyes are somewhat inclined to look across each other, like the roofs of the old parsonage: yet a clear skin, clean white teeth, though not very even, and a look of neatness and cheerfulness, in spite of these irregularities, made me look at her with pleasure; and I...should like very well to take the living, the house, and its inhabitant. You, Hamilton, I suppose, were thinking, how age and neglect would operate upon her as upon the house, and how simply picturesque she would become, when her cheeks were a little furrowed and weather-stained, and her teeth had got a slight incrustation.'

'No, indeed,' said the other, 'I thought of her much as you did; and I was reflecting how great a conformity there is between our tastes for the sex, and for other objects' (Price 1810 (v3): 291–2).

This fictional dialogue produced a real-life dispute between its author and Richard Payne Knight. In his *Analytical Inquiry* into taste (1805), Knight pointed out that, to be consistent with his ideals of picturesque beauty, Price's character should have mentioned irregularities in the young woman's figure, as well as her face: 'and consequently she must have hobbled as well as squinted ; and had hips and shoulders as irregular as her teeth, cheeks, and eyebrows'.[11] Uvedale Price would not back down from his attempt to link male sexual preferences with picturesque beauty, however, and merely added a few clarificatory remarks to the later edition of his essay. The debate between Price and Knight on the sexual merits of the picturesque has the absurdity of a logic carried to excess.

Although the discourses of the picturesque and the sublime were new in the eighteenth century, the tradition of finding analogies between styles of architecture and types of human beauty can be traced back to Vitruvius' the Roman treatise of *De Architectura* probably written during the first century B.C.. For Vitruvius, the Doric style showed 'manly beauty, naked and unadorned', but the other two main architectural styles – the Ionic and the Corinthian – were feminine. (Vitruvius n.d.: 104). In subsequent centuries, Vitruvius's authority – and his gendering of architecture was used extensively as part of a rhetoric of maintaining architectural purity. Thus, for example, the Frenchman R. Freart de Chambray used the authority of Vitruvius to argue against a 'Custom which has licentiously been introduced' and which is 'strangely debauched': of adding bases to the robust proportions of the Doric. The (properly) masculine Doric column should have the strength of a bare-footed Hercules,

instead of being ornamented (and made decadent and effeminate) by the architectural equivalent of shoes (Freart de Cambray 1651: 16).

Even earlier, in 1563, John Shute could be found representing the different architectural orders by elaborate, and strongly gendered, human figures. It was the body of Hercules – excessively muscular, and clothed only in an animal skin – which Shute used to model the proportions of a Doric column. In the Vitruvian tradition, the snail-like volutes of the Ionic capital were compared to the gentle curls of female hair. Accordingly, Shute modelled his Ionic column against the figure of Juno. The figure Shute used to represent the Corinthian column was more maidenly (Shute 1563: plates 6, 8, 11). Here again there was a visual reference to Vitruvius's account of the origins of the acanthus-leaf decoration of the Corinthian capital. The inspiration for this was said to be a maiden of Corinth who died before her wedding day, and whose belongings were gathered together in a basket that was placed on top of her tomb and held down by a roof tile. In the spring an acanthus root was found to have sprouted through the basket, its foliage bending outwards round the corners of the tile. When Callimachus passed by he was inspired to build some columns with that pattern for the Corinthians, transferring the imagery to the top of the high capitals that typify the Corinthian column. The story positions the virginal woman as bound to nature: her body opened up by the fertility of the acanthus root and able to inspire the male observer to create great works of art. Earth and heaven, nature and art, past and future, death and the infinite are mediated by her dead, but fecund body.

In the series of lectures on art that F. W. J. Schelling delivered from 1801–5, the German Romantic philosopher expressed scepticism only about the details of Vitruvius's story – not about the 'universal necessity' underlying it (Schelling 1859: 175–80). However, this so-called 'universal necessity' is only a cultural necessity: it relies on a bonding between woman and nature which reaches deep into the history of the West, but which has itself been transmuted in the course of that history. Although feminist cultural historians sometimes suggest that this bond was represented in a merely reductive fashion after the industrial and agricultural revolutions of the Enlightenment period, Schelling's use of Vitruvius suggests that this is misleading – as does the fashion for the picturesque which was so important in Europe during the time of those revolutions. Modern Euro-American man did not simply downgrade nature – and woman – from the eighteenth century on, as Carolyn Merchant would have us believe when she comments:

Nature-culture dualism is a key factor in Western civilization's advance at the expense of nature. As the unifying bonds of the older hierarchical cosmos were severed, European culture set itself above and apart from all that was symbolised by nature. An organically oriented mentality in which female principles played an important role was undermined and replaced by a mechanically oriented mentality that either eliminated or used female principles in an exploitative manner.[12]

What my analysis of the picturesque suggests, by contrast, is not that nature has been denigrated in any simple fashion in Western Modernity. A brutalising and instrumental approach to nature did, of course, intensify. But also the very wildness and savagery of nature was idealised, emphasised and promoted as desirable – as long as its potential for disorder could be contained by the controlling power of the male author or male spectator. Much the same seems true of the attitude to woman under Modernity. Middle-class women have been encouraged to render themselves weak, passive, gentle, nurturers: the 'Angels in the House' of Victorian times. But there hasn't been only one ideal of feminine beauty from the eighteenth century on. Indeed, the Burkean beauty – soft, smooth, delicate, harmless – was not the feminine ideal that most exercised the imagination of poets and artists. The figure of a more disturbing form of femininity remained – a potential sublime; powerful; ever-elusive; ever-threatening; a potential danger to the male ego – but reduced to the merely picturesque, framed into stasis by the male gaze.[13] It is this celebration – but also control of – woman as threat that is much more typical of Modernity than a simple denigration of femininity or nature itself.

'Here beauty is indeed – Beauty lying in the lap of Horrour!'[14] In this phrase uttered on first encountering Lake Derwent, we have the recipe for the picturesque. The ultimate horror – infinity, chaos, *Queen Sublime* – is prettified. It cannot be registered – it is too horrid – but neither can it be simply denied: the horror has its own attractions. The picturesque exists in a twilight zone: between light and darkness; clarity and obscurity; pleasure and pain; irritation and desire. The dreadful 'lap of Horrour' must be ornamented; softened; disguised by additions of the beautiful, flowers and figurative (and non-figurative) ivy leaves. It is hard not to read the discourse of the picturesque through Freudian theory, and interpret the 'lap of Horrour' in terms of the ultimate male fear: of female difference. Sublime power has to be conceptualised on the model of the male body. The picturesque traveller,

gardener and architect devised images – re-arranged towers – to replace their worst imaginings: of the unformed; of lack and absence; of woman as a castrated and potentially castrating 'lap of Horrour'.

For feminists who adopt Merchant's reading of history, there is no problem in envisaging a feminist aesthetic. For them a feminist aesthetic will be allied, simply, with a feminine aesthetic – and with a purer, more immediate, relationship to nature. Indeed, for optimists, all that will be necessary is to reach far enough back into the history of the West to find inspiration in the relics of some bygone age in which man was more in tune with the earth. However, on my reading of history, no such strategy is open to feminist artists. Males have appropriated images of nature as power – and woman as sublime – to promote an aesthetic of the picturesque: of wildness, woman, nature as potentially disruptive, but brought under control. As such, feminist artists are unable simply to adopt such imagery, unless they also adopt devices that disturb the pictorial conventions for maintaining distance between art-object and observer. And it is in the medium of photography – in which the traditions of viewing reality merely 'as a picture' are so strong – that is particularly problematic to transcend the merely picturesque, and represent a female sublime.

I read Jane Brettle's photographic work for this publication as a challenge to the conventions that lead us to associate the sublime with an idealised form of male power. One of her computer-generated images quotes – and ironises – Shute's figure of Doric man, in which the over-muscular maleness of Hercules acted as the signifier for supreme architectural strength. And in her photographs of architectural fragments from Turkey, she presents us with monuments of goddesses: massive, lying in ruins, bonded to nature, overlaid by time and lost to representation in their entirety. Her images are evocative of a time (a lost time? an impossible time?) in which women had power. 'EROR' reads one of the inscriptions on her decontextualised ruins. The broken word seems to signify an *error* in the way that gender has been encoded in the history of the West. These traces of cultural absence recall a definition of femininity offered by the feminist Lacanian psychoanalyst, Michèle Montrelay, who argued that in our culture woman functions as the ruins of representation.[15] In another of Brettle's photographs, a rope is tensed round a fragment of a column in a temple at Claros containing fragments of Leto, the forgotten mother of Apollo and of his sister, Artemis. The present pulls against the past; tries to dislodge it; meets resistance. In a further (enormous) photograph, from the same ruins, a gigantic sandalled foot looms

both tender and massive; solid, yet broken. Caught between strong shadow and bright sunlight, it captures the tensions inherent in the notion of a female sublime.

Some recent feminist theorists have advocated a re-awakening of the mythology of Demeter and Persephone, in order that women be given a counter to the father/son relationships and Oedipal rivalries which male cultural critics have seen as integral to the aesthetic pleasure of the sublime (Spitz 1990: 411–20). But images and narratives of the female sublime involve difficult manipulations of time and space. We are conditioned into non-feminist readings of female power. Queen sublime has been rendered non-threatening by being contained within the specularising gaze of the picturesque. Analogously, tales of matriarchy and female goddesses have been recouped by male narratives that consign them to an early stage of evolutionary history. It is no accident that Bachofen's influential accounts of a matriarchal past were specifically designed to prove women inferior, by showing how civilisation has moved on past this 'primitive' stage. Through Bachofen's influence – and that of Hegel, Engels, Freud – narratives and images of the supplanted mothers are deeply embedded in the mythical landscape of patriarchal power. The power/tower of the phallus has, indeed, been sustained by the thesis that femininity can only exist as the ruined *Other* – *against* which civilisation and the symbolic order is constructed.

How, then are we to blow up this tower in such a way that its fragments will not become merely overgrown with ivy, and re-incorporated into the specularised image of a non-threatening picturesque? How can we stop becoming merely a part of that *Otherness* against which male identity and Western 'civilisation' are secured? Within the tradition of picturesque art, a woman who transcends the beautiful does not represent the sublime, but is symbolically bonded to an idealised form of ruin and decay. Beyond the idealised refinements of modern Western culture, she nevertheless presents no real threat to that culture. The female sublime is subject to temporal control, as well as being spatially contained. Pictorial and narrative devices will have to be adopted by feminist artists and photographers to break down the spectator/artwork boundary and shock us out of our tendency to register the imagery of a female sublime in merely picturesque terms. The very conventions for framing and specularising have themselves to be critiqued.

I hope this essay has made it clear that I disagree with those psychoanalytic feminists who suggest that there are universal and inevitable reasons which make the gaze always and necessarily male (see, for example, Kaplan 1984; Mulvey 1989).

Against them, I would argue that the conventions of seeing woman as an object have been historically constructed, and have altered through time. What I am also suggesting, however, is that it is no easy matter to view from a position which does not reinforce the binary divide which positions the ideal woman as beautiful; but which uses the ideal male body and mind as the signifier for power. The existence of the historical category of the picturesque shows just how pointless it would be to seek simply to reverse the sublime = masculine and beautiful = feminine alignments. For within the tradition of the picturesque, aesthetic and sexual boundaries are broken down, and liminality negotiated; but in ways that lack the power to disturb the politics of patriarchal Modernity.

If femininity is symbolically allied with the ruins of representation, a spectator will tend to elide images of a female sublime with that which is outside modern culture. A ruin she will tend to see only Gilpin's picturesque 'Rooted for ages in the soil, assimilated to it' – a 'sacred thing', but without disruptive force – a 'work of nature', rather than art. In her work Jane Brettle has adopted a number of non standard representational devices: photographs bleeding off the edges of pages; superimposed images; ironic juxtaposition of figures; off-centre pictures; bolts stapling the work in the exhibition space; startling use of colour and size; banners that extrude the gallery into the street. All seem attempts to disrupt and dislocate the boundaries of the self/other relationship as mediated via the controlling spectatorial gaze. It follows from my argument that a feminist sublime in photography would have to employ analogous jolts to the frameworks of aesthetic visual control.

Women focus differently on the conventions which have been used to render them objects, since they stand in a different relationship with the history of those conventions than do men. As such, the possibility of distinctively female perspectives must be allowed – although these perspectives will themselves be historically and culturally variable, and will not be accessible to all women simply in virtue of having been born female. In our culture, the conventions for pictorial representation and viewing have been shaped by male fears and male desires. It is only by adopting visual shocks that one woman can enable another to see with a doubleness of vision – irony, parody, anger, satire, humour, mimicry – which is a necessary part of gazing as a female within a culture that adopts the male viewing position as norm.

A feminist aesthetic concerns itself with female gazers. But female gazers have to be more cross-eyed than the picturesque beauty in Uvedale Price's dialogue: they have

to disturb the directness of the male gaze, by looking in (more than) two directions at once. Women live in a patriarchal culture and see in images – and think in concepts – that come to them from that past. Even their knowledge of their own bodies and minds will be mediated by a culture in which the male provides both the ideal and the norm for human development and activity. And since the reality of the present is given highlights and shading via the distorting camera obscura of a patriarchal past, we cannot simply reach back nostalgically into that past for images or figures that can subvert the present in a direct or celebratory way. Rather, the conventions for visualising have themselves also to be questioned. In particular, feminists need to disrupt the boundaries of the photographic frame that has been used to aestheticise – and render harmless – images of female power.

Notes

1　Gilpin 1786, quoted Hussey 1927: 196.

2　Loudon, writing in 1806, is quoted Hussey 1927: 222.

3　M.G.J. Gravesande's warning of 1755 is quoted in Scharf 1974: 21.

4　Irigary (1974) argues that just such a specularising gaze plays a role in constituting the self/other relationship in the history of Western metaphysics and psychoanalysis. However, she does not register changes in the mode of specularisation. Her tendency to treat patriarchy as a monolithic whole from ancient Greek times to the present means that the feminist aesthetic that I advocate at the end of this essay departs from that offered by her.

5　See Battersby 1989.

6　Act 4, scene 2 of Richard Steele's 1703 play quoted Hussey 1927: 32.

7　For relevant quotes from J.J. Rousseau's 1758 'Letter to M. d'Alembert' and I. Kant's 1764 *Observations on the Feelings of the Beautiful and the Sublime* see Battersby 1989: 36, 77.

8　Thomas Warton's 1747 poem quoted Hussey 1927: 194.

9　See Battersby 1989, especially chapter 3, and Schiesari 1992.

10　Compare Price 1810 (v1): 199 with Gilpin 1782: 33–4.

11　Knight 1805 quoted Hussey: 74.

12　Merchant 1980: 2. A similar objection is in Klinger 1990: 64.

13　See, for example, Dijkstra 1986.

14　Gilpin 1786 (v1): 186 ascribes the phrase to a Mr Avison. See Hussey 1927: 84 for the claim that this typifies the response of the picturesque traveller.

15　Most of Montrelay is untranslated, but see her 'Inquiry into Femininity' in Moi 1987.

Bibliography

Austen, Jane (1811) *Sense and Sensibility*, reprinted New York, Signet Classics, 1961.

Battersby, Christine (1989) *Gender and Genius: Towards a Feminist Aesthetic*, Bloomington, Indiana University Press, and London, Womens' Press.

Burke, Edmund (1757) *A Philosophical Enquiry into the Origin of Our Ideas of the Beautiful and the Sublime*, 2nd 1759 ed. James T. Boulton, Oxford, Basil Blackwell, 1987.

Dijkstra, Bram (1986) *Idols of Perversity: Fantasies of Feminine Evil in Fin-de-Siècle Culture*, Oxford, Oxford University Press.

Freart de Chambray, R. (1651) 'A Parallel of The Ancient Architecture with the Modern', trans. in John Evelyn, *Evelyn's Architecture*, London, 1733.

Gilpin, William (1782) *Observations on the River Wye and several parts of South Wales, etc. relative chiefly to picturesque Beauty*, facsimile edn, Richmond, Richmond Co., 1973.

Gilpin, William (1786) *Observations, relative chiefly to picturesque Beauty … on the Lakes of Cumberland and Westmoreland*, (2 vols), facsimile edn, Richmond, Richmond Co, 1973.

Gilpin, William (1794) *Three Essays … to which is added a Poem, on Landscape Painting*, 2nd edn, facsimile edn, Farnborough, Gregg International Publishers, 1972.

Hussey, Christopher (1927) *The Picturesque: Studies in a Point of View*, London, G. P. Putnam's Sons.

Irigaray, Luce (1974) *Speculum of the Other Woman*, trans. Gillian C. Gill, Cornell University Press, 1985.

Kaplan, E. A. (1984) 'Is the Gaze male? in A. Snitow et al. (eds), *Desire: The Politics of Sexuality*, London, Virago.

Klinger, Cornelia (1990) 'Frau – Landschaft – Kunstwerk. Gegenwelten oder Reservoire des Patriarchats?' in Herta Nagl-Docekal (ed.) *Feministische Philosophie*, Vienna, R. Oldenbourg.

Knight, Richard Payne (1805) *Analytical Inquiry into the Principles of Taste*, in Hussey 1927.

Merchant, Carolyn (1980) *The Death of Nature*, San Francisco, Harper and Row.

Moi, Toril (1987), *French Feminist Thought*, Oxford, New York, Basil Blackwell.

Mulvey, Laura (1989) *Visual and Other Pleasures*, Basingstoke, Macmillan.

Peacock, Thomas (1816) *Headlong Hall*, ed. J. B. Priestley, London, Pan Books, 1967.

Price, Uvedale (1810) *Essays on the Picturesque (as compared with the Sublime and the Beautiful, for the purposes of improving real landscape)*, (3 vols), London, Mawnan.

Scharf, Aaron (1974) *Art and Photography*, Harmondsworth, Penguin.

Schelling, F. W. J. (1859) *The Philosophy of Art,* ed. and trans. D. W. Stott, University of Minnesota Press, 1989.

Schiesari, Juliana (1992) *The Gendering of Melancholia: Feminism, Psychoanalysis, and the Symbolics of Loss in Renaissance Literature*, Cornell University Press.

Shute, John (1563) *The First and Chief Grounds of Architecture, Paynter and Archytecte*, facsimile edn, London, Country Life Ltd, 1952.

Spitz, Ellen Handler (1990) in *The Journal of Aesthetics and Art Criticism*, 48, 4 (Feminist Aesthetics Issue).

Vitruvius (n.d.) *The Ten Books of Architecture*, trans. M. W. Morgan, New York, Dover, 1961.

TRANSFUSION

photo works

Ruth Ritchie Stirling

R E U N I O N

Scottish seventeenth century ceilings Clyde estuary Strath sea links clyde Kincardineshire

S P A C E

for

S a i n t
M a u r a

6 5 0 — 2 0 0 0

Site Specific

St Maura (c. 650–700AD) is first mentioned
in the Aberdeen Brevorium and then in the
Annals of Tigernac (Annals of Ulster) in 714AD.
She set up an independent school for women
on the island of Cumbrae.
On the probable site of that school is a house
named Strahoun, in whose grounds a church was
built, unwittingly, in the 1870s.

Pat Allen

Ilfochrome Print; Brass, wood, wool.

CREATION
v
REACTION

Skelmorlie Aisle (1638), Largs

The burial place for Sir Robert Montgomerie and
his wife Dame Margaret Douglas. The painted
barrel–vaulted ceiling imitates a vault of stone.
The decoration is fitted into the compartments
formed by ribs.

Under the care of the Secretary of State for Scotland

Ilfochrome Print and two hats

a M u s e
a M a s s

The Cathedral of the Isles

'The community of St Andrews of Scotland went
from Joppa to live in the North College in the 1920s.
This was initiated by Miss Grant in 1867, with
herself as Superior under the style of Sister (later
Mother) Regina. Mother Regina was the first
Episcopalian religious to be professed in Scotland
and the community was the first indigenous one
to be founded in the country'.

Provost David Macubbin

Ilfochrome Print and Harp

W o r d

a s

F / a c t

St Marys Chapel, Grandtully

The earliest record we have of the chapel is a charter
of 1533 by which Alexander Stewart of Grandtully
gave lands to the priory of St Andrews as endowment
for a priest to serve there. During the 1630s, a period
of great religious upheaval was started by the Kings'
attempts to impose Anglican forms of worship on the
Scottish Church. This culminated in the national
covenant of 1638 and abolition of the bishops at the
Glasgow Assembly.

Ilfochrome and rope

12 to 5 lines
Spaces
and key

The Muses Room

Katherine Burnett's workroom at Crathes Castle,
Kincardineshire, c1630. The ceiling contains sixteen
female figures, nine muses and seven Virtues. The
text contains the Key or Clef.
Under the care of the National Trust for Scotland

Ilfochrome and propeller

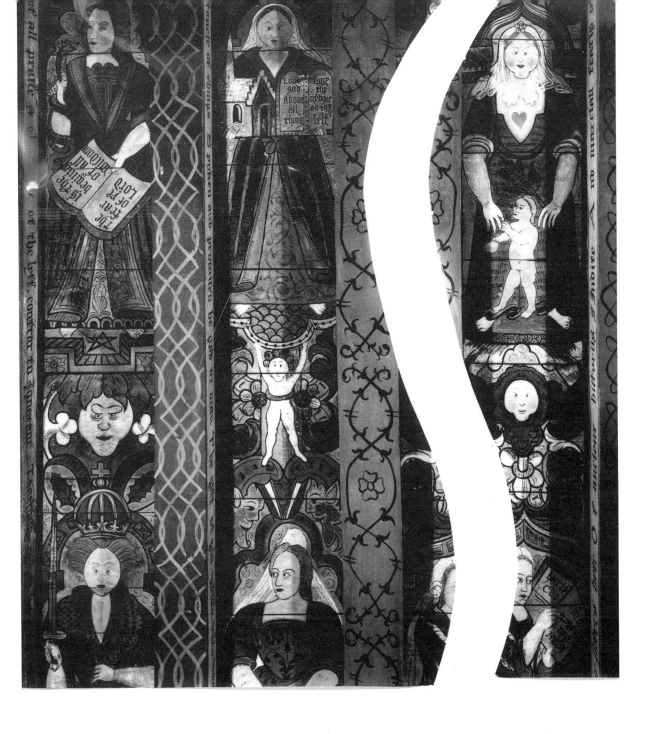

Beadle
&
Honey

The Sailors Gallery The Farmers Gallery The Lairds Gallery

1591

'The Beadle, as well as rousing sleepers, and ringing
bells had other duties such as carrying a "red wand"
in church, to remove "greeting bairns furth of the
kirk." This matter of women sleeping on the floor
might well have been brought about by the order
forbidding them "to sit on or occupy the forms used
by the men" and further stating that they must bring
with them "ane stool to sit upon or else be content to
sit low upon the floor.' From the book by J.S Bolton

In 1841, the church closed. The church was
transferred from the original site and rebuilt, stone
by stone in 1928. Re-formed and Re-ne-wed.

Ilfochrome print, straw, honey and glass

S a l t

Clerestory window: A window hau

St Vincent Free Chu

The building was designed by Alexander Thomson, and was opened in 1859. It to
inspiration from Classical architecture which he applied to his own 'g

Talks

cross piece to divide the light

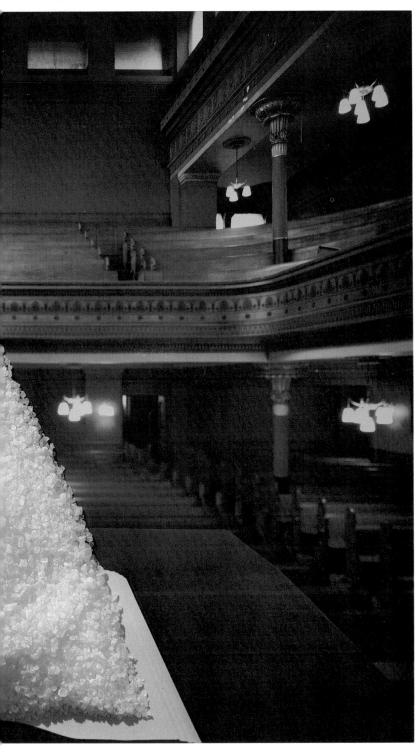

Scotland, Glasgow

...son's daring use of slender cast iron columns which emerge from below, support ...allery and massive stone clerestory.

'Context/act'

John, Chapter eight, Verses six and seven

Librate/etto

Transfusion & Communion

St Mary's Chapel,
Grandtully

Galations 3 Verse 28

Agnus Dei,

Qui tollis pecatta
mundi:

miserere nobis,

Agnus Dei,
dona nobis pacem

qui tollis pecatta
mundi

Ilfochrome, perspex tubing wine, milk

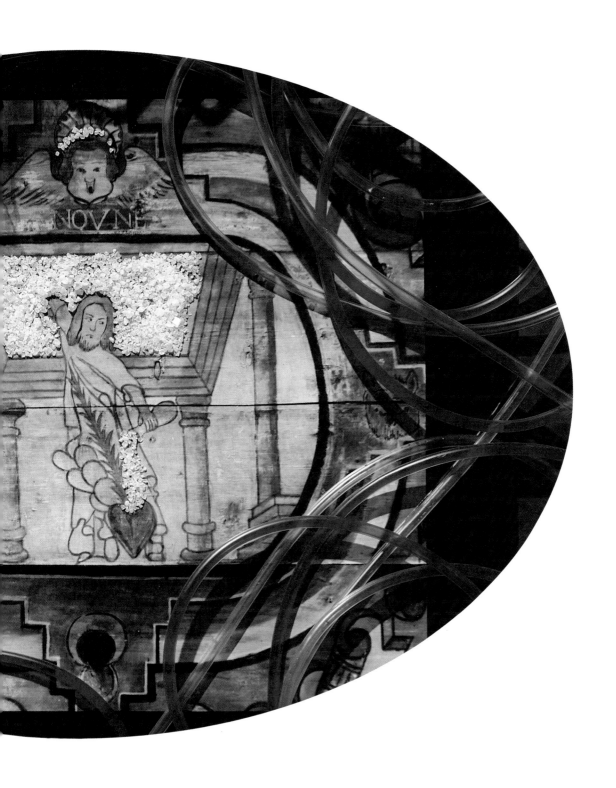

Common/union

COMMUNION

Women, theology and the embodiment of truth

Mary Grey

THE QUESTION 'What is truth?' is asked today in the context of post-modernism. This would seem to offer Pontius Pilate a way out. He can wash his hands of truth in good company today, in a climate where both philosopher and theologian appear to have given up on the search. Since the collapse of the grand systems of modernism – Freud, Hegel, Marx, for example – the tendency has become to distrust any attempt to impose universal meaning on events and on interpretations of history. Truth is seen as concrete, particular and arising from context.

But does this mean a lapse into total relativism, an endless succession of contextual interpretations?

Are there no absolute doctrinal truths?

I suggest that such a system would be destructive to feminism and certainly to religious belief and that a much more nuanced understanding of the 'post-modern condition' is called for – a position hinted at, but not developed, in Hans Kung's recent book *Global Responsibility: in Search of a New World Ethic* (Kung 1991).

Secondly, feminist theology cannot disassociate itself completely from the achievements of modernism. It owes its very existence to the rationalism of the Enlightenment which produced the Declaration of Human Rights, thus sparking off the struggle for equal rights for women.[1] A certain trust in the 'commonality of reason' is a prerequisite for the most basic level of communication.

Thirdly, to lapse completely into the relativism of our concrete situation, is a non-starter for meaningful communication with our fellow human beings. For it suggests an entrenched position which admits of no real enrichment and growth through shared insights.

We have certainly learned from the post-modernist critique that we can no longer understand truth as a simple correlation with 'reality', for reality and our experience of it are coloured by interpretation. Reality is also constructed – whether we are speaking of a theological, philosophical, or scientific construction. This means it is naive to seek theological truths in a 'return to origins', 'how it really was',

whether we are speaking of the Garden of Eden, or the beginnings of Christianity.

Rather, as the liberation theologian Dorothee Soelle, whose theology was influenced first by shame at the German treatment of the Jews in the Second World War and later by the horrors of the Vietnam war, wrote in 1974:

> The truth of Christ exists only as a concrete realisation, which means: the verification of every theological statement is the praxis that it enables for the future. This means that theological statements contain as much truth as they deliver practically in transforming reality (Soelle 1974).

But before unpacking this concept of truth which Dorothee Soelle offers – the praxis of transforming reality – which is being developed in feminist theology, the implications of reality as a construct need unpacking. It was Michel Foucault who exposed history not as a steady pursuit of truth, but the history of the will to truth: history is not the disinterested story of the human race; it is a controlled interpretation of events by the few (male) figures who have held the reins of power, a history:

> In which the distinction between true and false is shown to be contingent, shifting, beyond our grasp and conscious control. Whose knowledge is given authority? What sorts of warrants are acceptable? Which institutions purvey knowledge and create knowers? (Foucault 1973: 9).

We are already seeing the prophetic quality of these words in the inexorable progress of a technology , at times ruthless in its exploitation of local population and environment. We are confronted by our refusal to 'make the connections' between power and the 'truth of history'. Foucault has uncovered in a dramatic way both the link between truth and power and the 'epistemic shifts' determining what we perceive, think and know in the different periods of human development. It was his call for the 'insurrection of the subjugated knowledges' which was to prove so influential for feminist liberation theology (Foucault 1980: 81–2). The subjugated knowledges refer to 'the specific history, the history of subjugation, conflict and denomination, lost in an all encompassing theoretical framework or erased in a triumphal history of ideas' (Foucault 1973: 19). They are the knowledges , the hidden wisdom of women, of ethnic minorities, the indigenous peoples , pushed to the margins of culture. The wisdom of the lore of the earth itself has vanished from this triumphal view of history.

A deliberate choice

For Feminist Liberation Theology, writes Sharon Welch in '*Communities of Resistance and Solidarity*' (Welch 1985), this means specifically proclaiming the epistemological privilege of the oppressed, this means deliberately choosing to think and act from the perspective of the oppressed and the ethnically marginalised, through solidarity of lifestyle and a 'culture of resistance'; such a 'culture of resistance' was manifested in recent years by the communities growing up outside the peace camps in protest against cruise missiles, as well as by the 'Mothers of the Missing Ones' in Argentina. A culture of resistance protests – but at the same time lives by a different vision of society; it is thus at the same time a culture of hope. However, it also recognises the temporary nature of that choice and the possibility of its perspective being superseded. It means paying attention to the gaps, silences and fissures of universal discourse, including the silence of liberal theology as to the experience of women. 'Knowing' becomes something completely different when approached from 'the underside of history', as one becomes aware of the prejudices of race, sex and class, which have shaped our perceptions of what is true. As Professor Chung Hyun Kyung, who delighted the World Council of Churches Assembly at Canberra with her sermon 'Come Holy Spirit' writes:

> This knowing is different from that of the privileged men who are the cause of Asian women's pain and suffering. Asian women's epistemology is *an epistemology from the broken body*, a broken body longing for healing and wholeness (Chung Hyun Kyung 1990: 39).

The process of coming to know is shaped by the stories of exclusion and suffering, by a culture of resistance, and by the 'dangerous memory of suffering', the '*memoria passionis*', of freedom and resistance. Thus a different concept of truth emerges. When we understand the unjust power relations involved in a particular institution – a political regime, the prison system, a multinational – we become sceptical and critical of what passes for truth, faithful to the epistemological privilege of the oppressed . We become challenged to a different way of knowing 'empathic knowing', or connected knowing: not a passive form of empathy which acquiesces in exploitative systems, or stereotypical prejudices that 'the poor' and in particular 'poor women' are destined to suffer, but an empathic knowing which inspires a different praxis. Thus theological

truth begins to emerge – as Dorothee Soelle hinted – in the statements of transformative praxis.

Susan Thistlewaite, resisting both the the total relativism of Foucault and the claims of Mary Daly to have discovered 'true being' through the experience of women, explores the idea of 'truth in action'. Invoking the epistemology of Sojourner Truth, the Black African women who struggled against slavery, she writes that 'sojourning' or living for a while in the new reality is the way we change our ideas about the world (Thistlethwaite 1990: 12). 'Truth in action' is discovered and lived by being faithful to communities of solidarity and resistance, both in the southern hemisphere of the world and here in Europe, in the grass-roots movements for justice. It is a much more dynamic notion than the basic feminist notion of bonding – where the danger is that bonding is stressed, while 'difference' is swept under the carpet .

The 'communities of solidarity and resistance' are given a Christian and ecclesiological meaning by the American feminist pastoral theologian Rebecca Chopp: where the Spirit is fully united with the spirit of community, the gifts of the Spirit for communities of emancipatory transformation – justice, vitality, wisdom and love – can arise (Chopp 1989: 96–8). But before exploring this, I first want to show how 'truth in action' within an epistemological privilege for the poor, and those excluded from public discourse, is based on a different notion of logic, or pattern of thinking and a non dualistic way of 'coming to know'.

A listening logic

The French philosopher Simone Weil made a strange observation at the end of her life that 'in Shakespeare, only the fools tell the truth'.[2] But who listens to fools?

If we include in the meaning of 'fools' those whose discourse is unheard or excluded by the powerful – the elderly and the chronically sick, the mentally handicapped, sexually disenfranchised, the racially discriminated against and ethnic minorities, refugees, prisoners, the religious sects considered by the Churches to be 'on the fringes' and then admit that within all these groups many women are disadvantaged – then we have to ask the question as to the basis of the logic in which the public discourse is being conducted. What epistemic presuppositions allow it to exclude vast sections of humanity?

The problem is that the logic we have inherited from our tradition – through for

example the Socratic method, through Peter Abelard's treatise *Sic et Non* followed by medieval scholasticism, is the confrontational, exclusive logic of 'either – or', yes or no.[3] What is more, clarity and profundity of thought – since the work of Francis Bacon – are closely wedded to detachment, disengagement and objectivity. (These qualities are also rated highly by the medical profession: the more ill the patient is, the more the doctor must flee the emotional involvement.) When one moves these qualities out of the sphere of 'textbook logic' and into the spheres of lawcourt, marriage tribunal, psychiatric institutions, and remember that in the Middle Ages the Church controlled the courts, we begin to see the enormous oppressive power which a confrontational logic can wield.

The point I want to stress here is that it is particularly at times when the fabric of the community collapses – as it did in Athens at the collapse of the city-state, as it is doing now with the collapse of the Soviet Union and the Yugoslavian federation – that a narrow, confrontational and oppressive logic re-asserts itself, for example, in the cry for the return of the death penalty in the United States. This restrictive logic of conformity erodes the very principle of freedom and exploration, that love of wisdom – 'philo-sophia' – on which university education is built, so that any branch of learning which does not directly contribute to industrial output or economic growth becomes an expendable irrelevancy. Our 'civilisation' has emptied morals of absolute values and crucifies its own creativity.

But suppose we developed another logic, non-confrontational and inclusive, a logic born of experiences on the margins, a logic which witnesses to another kind of truth, a logic faithful to the 'epistemology of the broken body' to which Professor Chung referred?

Suppose it was a logic born not of the detached wielding of power, but of the struggle to survive?

The Italian scholar Gemma Corrado Fiumara has called for the recovery of a 'listening logic' (Fiumara 1990). This, she claims, is not just a technique for listening to marginal discourse, but inherent in the very meaning of logic itself. She calls us back to a forgotten, buried meaning of *logos, legein,* namely not just as speech or discourse, but as a 'gathering together, a laying side by side, and a safe keeping' (Fiumara 1990: 4–5). Heidegger, she claims, declared that hearing was proper to *logos* and called for a logic that was 'co-existence with' rather than 'knowledge of', with all the detachment and objectivity which this implies.

Instead of a cult of speech, says Fiumara, evoking a forgotten notion of Socrates (from Plato's *Theaetetus),* ' we should cultivate a maieutics of listening, the bringing to birth of new ideas, and perceive the lost connections even in the midst of the waves and storms of cultural co-existence' (Fiumara: 162). Only then would we recognise that thought, far from being a weapon used to destroy – either an argument or a person – is in fact 'midwife thinking', the risky venture of giving birth to an idea, which may involve loss both to the one giving birth and to what is born.

The task of the midwife philosopher, says Fiumara, is the nurturing of the nascent thought before it is irremediably swallowed by rigid or stultified cultural forms (Fiumara: 159). (This is reminiscent of Julia Kristeva's distinction between the semiotic and the symbolic forms – the latter being the level at which the former can be crushed or excluded) (Kristeva 1986: 187–213). Conversely, the snuffing-out of philosophical midwifery is the precondition for the spreading of our thinking in repetitive and unrelated forms, contrasting only in appearance. The logocentric model *par excellence* is the labyrinth, where Ariadne's thread presents the sole linear model of escape.

A different method

It is through this 'listening logic' that we are becoming aware of other ways of knowing issuing from Christian feminist base communities, Women Church groups, Refuge groups against domestic violence and so on, which I believe are offering us a different method for embodying truth. First of all, the shared premise of such groups is a 'hearing into speech'; that is, a sensitive listening which enables a person rendered inarticulate through low self-image or through traumatic experience, to bring her experience into words. Low self-image means, literally that a woman has no picture of herself. She is rather a mirror reflecting the perceptions and needs of others – parents husband, children and religious authorities. Psychologist Jean Baker Miller remarks that women are frequently socialised to a 'mediated sense of self – to which the word "ego" need not be applied.' Being heard into speech , is being heard into subjectivity and self discovery. Secondly, such a listening logic is supported by a non-dualistic view of persons-in-relation. This admits a degree of openness and vulnerability to others, a recognition that the self-becoming of others is part of everyone's personal journey, and an attempt to integrate feeling , and bodily wisdom into the categories of thinking.

131

Called by Sara Ruddick, 'Maternal Thinking' by others 'Caring Knowing', 'Empathic Knowing', even 'Passionate Knowing', these are all attempts to articulate the different kind of knowledge which emerges from commitment to a praxis of liberation.

The study '*Womens Ways of Knowing*' has attempted to chart the process of coming to know of women marginalised by Church and society (Blenky *et al.* 1986). The writers show how it is possible to make progress from a state of total silence, not the silence of contemplation or deep relation but one enforced by oppression, violence and ineluctable cycles of poverty, or, in the silence of hostility and total lack of communication, reinforced by bitterness of historical memory. Next the process of 'coming to know' may lead to 'received knowing', where one passively accepts the learning of a teacher or priest or 'the authority'.

Seen from the perspective of relationships with fellow-citizens in a multi-faith society, this would mean the state of passively accepting received knowledge, opinions or prejudices about the 'Other', whether the other is a Christian, from another faith or from a secular context. Women as 'received knowers' find it almost impossible to move forwards, because firmly ingrained in the psyche is the conviction that 'truth' is enshrined in the publicly recognised authority.

The next stage in the process is the intuitive knowledge, the famous 'gut intuition' of one's own experience; this can mean real breakthrough, but gives no tool for recognising and accepting the intuition or subjective knowledge of anyone else. In situations of dialogue, or even within the same Christian community – as has been experienced in charismatic groups – this can lead to absolute impasse, or worse, the person falls back to a few 'absolute truths' at the 'received knowing' stage.

The fourth stage, that of procedural knowing – or the formal process of arguing – offers a way forwards in the sense of a critical tool to assess the validity of arguments. The problem can be that the full contextual richness gets lost in the formal process of argument.

Connected knowing

The final stage is that of constructed or connected knowing. This is an attempt to balance the conflicting voices – of body/mind, tradition/contemporary context, experiences of suffering and exclusion, memories of freedom and hope, the competing claims of gender, race and class, the conflicts between anthropocentrism and earth-

centrism. Connected knowing is based on a world-view of connectedness and inclusion, which believes that in the recognition of the organic interdependence of all living organisms within God's creation lies all hope of justice and harmonious living.

My next question must be, what has 'connected knowing' as epistemological method to offer in the sphere of communication in a multi-cultural, multi-faith society?

The epistemology emerging from the praxis of Feminist Liberation Theology has much to offer. First, it insists that the quality of hearing and listening is vital; who are the partners in the exchange and who is excluded? 'Hearing one another's truth' is thus the first and most important principle in groups set up to offer care in cases of rape and domestic violence (Fortune 1983).

Secondly, based on a respect for both dimensions – that of connectedness and that of otherness – yet working within an organic paradigm of 'relationship with the other', springs feminism's image of inclusive community. Any abuse of ecclesiastical authority clashes with feminism's vision of authority as located in the grassroots communities of the 'People of God'. Power also has a communitarian and relational base. Power is energy for justice, is birth-giving, and is made effective in commitment to dialogue towards the resolution of conflicts.[4]

Thirdly, Feminist theology is committed, on the basis of solidarity with the oppressed and mutuality as an ideal way of operating, to a recognition of 'difference' in its political, social and ecclesial consequences. Women are used to being classified as the 'other' where this either carried a negative connotation or was a pretext for non-recognition as fully human. Through – for example – Susan Thistlethwaite's stinging criticism of white middle-class feminism's blindness to its own racism, its collusion in the oppression of women of colour, its reduction of feminism to its own agenda, there is now a growing attempt to explore and cherish ongoing differences. There is a growing realisation that feminism and feminist base communities can never form a homogeneous whole, but rather, to use Elizabeth Schussler-Fiorenza's phrase, 'they are like an open space yet bounded, of overlapping discourses and communities' (Schussler-Fiorenza 1990).

It is this struggle to cope with difference on the basis of ongoing relation which offers a parallel to the Inter Faith struggle. The Inter Faith movement could benefit from the fact that women have already crossed the boundaries and are working together across the faith divide – with Jews and Muslims, for example, on health

issues, family life, domestic violence, sexuality and racism.

Following on from this is the fourth point – a call to the Churches and major religions to change. Feminist theology challenges the traditional understandings of responsibility for evil because of the way these have scapegoated women. Not only does it issue a call to the Churches to make explicit gestures of reconciliation for its failure to hear the truth of the 'other', but it brings a gender perspective to bear on central doctrines of sin and redemption, and brings to light the patterns of thinking which could have made this possible.[5] There is an analogy between the (white, Western) feminist analysis of its own structural responsibility in the suffering of poor women (and men), and the Church's guilt both in the structural exclusion of women, and its failure to break down its own structures of exclusion and separation. Both of these must be given explicit ritual expression.

Fifthly – returning to the present context – Europe 1994; Feminist Liberation Theology's epistemological privilege of the oppressed issues a challenge to the Christian Churches in Europe with regard to the poverty, violence and suffering in Latin America. To what extent are our own neo-imperialist patterns of thinking responsible for the escalating poverty and environmental damage? To what extent have the churches backed oppressive regimes? Will a 'listening logic' hear the voice of the crucified peoples? Europe after 1994 cannot operate with the old theology of the cross. The cross was once forced on Jew and Muslim alike with fire and sword. It has been sentimentalised and idealised and even used as a means to encourage passive acceptance of suffering. Now it must be re-imaged, re-thought, from the position of the 'crucified peoples' themselves. The phrase is from Jon Sobrino, the Liberation Theologian from El Salvador (Sobrino 1992: 120–9). They do not need more crucifixion: they need our protest against it; and let the cross be re-imaged as both a memorial of innocent suffering and as a commitment to justice-making. No longer can we authentically interpret our commemoration of the sufferings of Jesus in an individualistic fashion, but rather as an urgent summons to struggle with the crucified peoples, that the dangerous memory of freedom never be lost. And this, finally, will be the criterion of Christian truth. How far can the Churches together undertake that liberating praxis which will enable 'Christian truth' to transform culture, not in the old rule of 'fire and sword' but in a praxis which, in hearing others into speech, makes that 'the hungry can eat again, the children can play again, the woman can…stand again… It is a power that drives to justice – and makes it?' (Heyward 1982).

Notes

1 For the complex relationship of feminism to the post-modern scene, see Lovibond 1989: 5–28; Coakley 1991: 75–83.

2 Cited in McClellan 1989: 265.

3 I have developed this theme in Grey 1992: 84–9.

4 On re-imaging of power, see Hurty.

5 See Grey, forthcoming.

Bibliography

Blenky, Mary Field et al. (1986) *Women's Ways of Knowing*, New York, Basic Books Inc.

Chopp, Rebecca (1989) *The Power to Speak: Feminism, Language and God*, New York, Crossroads.

Chung Hyun Kyung (1990) *Struggle to be the Sun Again: Introducing Asian Theology*, New York, Orbis.

Coakley, Sarah (1991) 'Gender and knowledge in Western philosophy', *Concilium*: 6.

Fiumara, Gemma Corrado (1990) *The Other Side of Language: a Philosophy of Listening*, London, New York, Routledge.

Fortune, Marie (1983) *Sexual Violence: The Unmentionable Sin – an Ethical and Pastoral Perspective*, New York, Crossroads.

Foucault, Michel (1973) *The Order of Things: An Archaeology of the Human Sciences*, in Welch (1985).

Foucault, Michel (1980) *Power/Knowledge: Selected Interviews and Other Writings* 1972–77, New York, Pantheon.

Grey, Mary (1992) 'The challenge of Heloise: language, truth and logic re-visited', *New Blackfriars*, February.

Grey, Mary (forthcoming) 'Falling into freedom: exploring new images of sin in a secular society', *Scottish Journal of Theology*.

Heyward, Carter (1982) *The Redemption of God: A Theology of Mutual Relation*, Washington, University of America Press.

Hurty, Kathleen S. (1991) 'Ecumenical leadership: power and women's voices', in Melanie A. May, (ed.) *Women and Church: the Challenge of Ecumenical Solidarity in an Age of Alienation*, New York, William B. Eerdmans, Grand Rapids.

Kristeva, Julia (1986) *Women's Time*, in Toril Moi, (ed.) *The Kristeva Reader*, Oxford, Blackwell.

Kung, Hans (1991) *Global Responsibility: In Search of a New World Ethic*, London, SCM.

Lovibond, Sabina (1989) 'Feminism and postmodernism', *New Left Review*, 178.

McClelland, David (1989) *Simone Weil: Utopian Pessimist*, London, Macmillan.

Schussler-Fiorenza, Elizabeth (1990) Public Lecture, St Jan's Cathedral, S'Hertogenbosch, September.

Sobrino, Jon (1990) 'The crucified peoples: Jahweh's suffering peoples today', *Concilium* (special issue).

Soelle, Dorothee (1974) *Political Theology*, Philadelphia, Fortress.

Thistlethwaite, Susan (1990) *Sex, Race and God*, London, Chapman.

Welch, Sharon (1985) *Communities of Resistance and Solidarity*, New York, Orbis.

CAVEAT SPONSA:
Violence and the Body in Law

Alison Young

It was rather something in the architecture of desire that required a sacrifice.
There was an altar, and a tradition of blood.
(Cooper 1992: 103)

...the fascination of sacrifice as an act which locates and deserts the body.
(Goodrich 1990: 306)

THE VIOLENCE that is the concern of this text is homicide committed within conjugal relationships between men and women. My intentions are to offer a reading of a case involving homicide in such a relationship, the homicide being committed by the woman; and to theorise the experience and commission of violence in law as intrinsically a question of sexual difference. My concern is not to construct a statistical account of the comparative incidence of so-called 'domestic violence' and the varying responses of agencies such as the police, the courts, the prisons; an account which could claim representativeness, objectivity and quantitative data collection as part of its 'truth'. My account will be partial, in the two exact senses of the word. Firstly, my reading is partial in that I am concerned to look no further than the case I will examine. Each and every conjugal homicide case deals with love, death, violence, betrayal and terror: emotions and experiences which should require no quantitative validation for an investigation of their creation and elaboration. To that extent, this text focuses on the limited and local narratives of one event. Secondly, my account is partial in that I write as a feminist, with feminist concerns. Further, this text is part of a separate and continuing interest into the construction of femininity and sexual difference within legal discourses; that interest inflects the progress of this piece.

The text will examine, by means of a reading of this case, the legal culture of violence within marriage. My aim is to trace the judicial drawing of a body in law – a body that is gendered, sexed and stretched across the divide of assailant/victim. The case to be considered is, no doubt, one that is well-known. For a time, the media took considerable interest in Sara Thornton – through (to date, the failure of) her appeals

against conviction, her hunger strike, and the persistence of a campaign demanding her release (the Free Sara Thornton campaign organised by Justice For Women). This interest has been displaced now in favour of other women who have successfully appealed against conviction or sentence – such as Kiranjit Ahulwalia, whose conviction for murder was quashed in July 1992 and who pleaded guilty to manslaughter by reason of diminished responsibility in September 1992, or Judith Gardiner whose sentence for manslaughter was reduced from five years imprisonment to two years on probation in October 1992. Nevertheless, no woman received such a sustained period of media attention; it is partly due to this and partly to the nature of her case and subsequent protest against conviction that Sara Thornton may be today the best-known battered woman who killed her abuser.

Sara Thornton had married a man who turned out to be a violent alcoholic. He beat her regularly; he threatened her life and that of her daughter. She had, on several occasions, called the police for emergency assistance, asked neighbours for help and contacted Alcoholics Anonymous. To one neighbour, one day, she said: 'I don't know what to do, I could kill him.' One night, her husband Malcolm returned home very drunk. They had argued earlier in the day. Thornton went to speak with him where he lay on the sofa. He swore at her, accused her of selling her body to other men, and threatened to kill her later. She went into the kitchen, sharpened a knife and returned with it to the sofa. She said later that she had been advised to do something like this by Alcoholics Anonymous, in order to protect herself and to make him see that she was serious. They spoke again; she asked him to come to bed; again he swore at her. To frighten him, she would later say, she raised the knife and slowly brought it down, stabbing him in the stomach. She said later that she expected him to stop her; also that she believed he would have killed her later. She told her son to call the police; when the police and an ambulance crew arrived and were attempting to help her husband, Thornton said: 'I don't know why you're bothering, he deserves to die.' He died four hours later, from loss of blood. Thornton was charged with murder.

This would be a rough summary of 'the facts' of the event, its details. A version similar to this appeared in newspaper and television reports, magazine features on women who kill; a television programme about battered women.[1] However, when the narrative appears in its legal form, subtle mutations, manipulations and metamorphoses occur. This is not to suggest that the above mentioned media accounts of the event, or indeed my version of it, have any purchase on the 'Truth' (whatever

that might be, and from which the legal account could be claimed to deviate). The 'Truth', if such a thing could exist, may be known only to the participants in the event; even then, I would argue that the accounts of victim and assailant would be dramatically different. (We can see this clearly in the Canadian case of Erica Eboli, charged with attempted murder: she pleaded 'battered women's syndrome' and was acquitted. Her husband claimed he was the battered one, and offered an account of their relationship and the event which differed in almost every respect from Erica's, coinciding only in the fact of his having been stabbed on that night).[2] Any notion of a search for 'Truth', whether presented in a participant's account or by means of a trial and inscribed in a law report, is therefore a chimeric notion which should invite scepticism.

In the case of Sara Thornton, the trial itself was not reported, existing only as quoted excerpts in the judgements of the Appeal Court. The appeal was reported in three different locations: the *Criminal Law Review*, the *New Law Journal* and the *All England Law Reports*. The latter constitutes the standard locus of reporting for cases in English law. I will concentrate on the *All England* report in my analysis of the legal narrativising of Sara Thornton's case.

A NARRATIVE OF LEGAL VIOLENCE
Violence as history: femininity as masquerade

The legal story begins with a summary of the event, but one which is already structured by a particular evaluative frame. The case report begins:

> The appellant (Sara Thornton), who began to suffer from a personality disorder while at school, met her husband in May 1987 and realised from the start of their relationship that he was a heavy drinker and was jealous and possessive. In August 1988 they were married. There was a history of domestic violence and assaults by the husband on the appellant and in May 1989 he committed a serious assault which led to charges being laid (*All England Law Reports*: 306).

I have quoted this in order to be able to analyse in detail several of the components of the legal construction of violence in marriage. I will deal with each in turn. First, Sara Thornton is referred to in this passage and throughout the case report as 'the

appellant'; Malcolm Thornton is here referred to as 'the husband' or 'her husband'. The woman is assigned to the impersonal, isolated place of the legal subject, the appellant, the one appealing against conviction. Her position as 'wife', 'woman' or 'battered wife/woman' is forgotten, left behind. She has been recategorised. Malcolm Thornton, on the other hand, remains defined in a relational identity. Instead of being called 'victim' or 'deceased', he is 'the husband', emphasising therefore the location of the event within their relationship.

Within the first sentence, we are told two things about Sara Thornton which are crucial to the subsequent structure of the legal narrative. First, we are told that she 'began to suffer from a personality disorder while at school'. At trial, Sara Thornton pleaded that she was suffering diminished responsibility at the time of the homicide. This was not accepted, due to differing psychiatric reports (the defence reports supported the claim that her responsibility was impaired at the time of the homicide; the prosecution psychiatrist disagreed). Despite this, the introduction to the case report deems Sara Thornton's personal mental abnormality sufficiently important to include it as a 'fact' in the first sentence of the report. Locating the inception of her personality disorder in her schooldays also serves to emphasise that she was 'not normal' before she became involved with Malcolm Thornton. (Later the reader is told that she was asked to leave her school: she is unstable and subject to problematic behaviour even then). Implicitly, such a move makes it impossible to claim, as proponents of 'battered women's syndrome' might,[3] that her violent reaction was rooted in the violence she herself had experienced at her husband's hands. Sara Thornton was unable to plead diminished responsibility and thus avoid a conviction for murder; however, the legal institution introduces her in its narrative as an actor who has a disordered personality. Her story thus becomes one of illogic, yet it is an illogic that cannot exculpate or mitigate.

The second part of the opening sentence is equally important: '...met her husband in May 1987 and realised from the start of their relationship that he was a heavy drinker and was jealous and possessive'. Immediately, Sara Thornton is blamed for her own miserable situation: she knew what Malcolm Thornton was like; he did not attempt to pretend he was a different type of person; there was no misrepresentation on his part. Sara Thornton herself states that she believed she could help Malcolm Thornton to change (Thornton 1992); Walker and Browne recount instances of battered women who married their batterers with the (mistaken) belief

that they could help their husbands to resist violence (Walker 1987; Browne 1987). The legal narrative shows no interest in such a motivation: knowledge (of alcoholism, jealousy and possessiveness) leads inexorably to its consequences ('a history of domestic violence and assaults' which followed upon the marriage). The *All England* report also tells the reader about Sara Thornton's previous relationships:

> after several relationships with young men which did not work out she met her first husband. She was then 23. She gave birth to a daughter the following year and initially the marriage was happy. However...she found her husband had begun to drink heavily. He was violent towards her, so she left him... On several occasions she attempted suicide, but it is questionable whether she actually intended to take her own life (308).

According to those who argue for the specificity of the position of the battered woman, Sara Thornton was existing within a matrix of experiences which could only spiral downwards: problems at school, at least two relationships with men who were alcoholic batterers. However, the court presents this in terms rather of her failure to create a successful family unit and even goes so far as to dismiss her suicide attempts as not meaning to take her own life.[4]

So far, the narrative has created a central character who is unreliable, unstable, abnormal, and a failure at family relationships.

There is a distinction in the report between the categories 'domestic violence' and 'assaults' – the report states: 'there was a history of domestic violence and assaults by the husband on the appellant and in May 1989 he committed a serious assault which led to charges being laid' (306). No details are afforded at any point in the narrative for the reader to understand what kinds of violent acts fall into one category rather than the other. Many commentators have criticised the legal fondness for the term 'domestic' in relation to violence between intimates.[5] As a descriptive term, it is unnecessary and functions only to diminish the seriousness of the term 'violence'. In the report, no information is provided about the violence Sara Thornton suffered, only bland blank terms such as 'domestic violence', 'assaults' and 'a serious assault'. The precise nature of the injuries, the horror, pain and betrayal are all left out. On the other hand, as I will discuss, the details of her acts are examined closely under the legal microscope.

The next piece of information included in the legal narrative relates to Sara

Thornton's so-called revelation to a woman, Mrs Thomas, that she was going to kill Malcolm Thornton. Walker's study of battered women who killed their abusers showed that many battered women engage in homicidal fantasies which are simple wishes for the abuse to end (Walker 1987: 106). A statement such as 'I am going to kill him' (*All England Law Reports* 1992 (1): 308) should not be taken as a straightforward expression of an intention to commit murder (as it appears to be in the case report). Even without the specificity lent to such a statement by Sara Thornton's position as a battered woman, it could express exasperation, frustration, anger or despair, without necessarily meaning that she was planning the homicide. The narrative accepts the possibility: 'but for subsequent events Mrs Thomas might well have dismissed this as no more than an expression of exasperation' (309). Are we to conclude from this that any such statement followed by a killing should automatically be understood to evidence murderous intent? The legal institution appears to have closed off the possibility that a battered woman could say such a thing, and later kill her husband through provocation, through diminished responsibility, through self-defence, as manslaughter: in short, as anything rather than murder.

The subsequent events which appear so compelling are described as follows:

> On the following day [Malcolm Thornton had been drinking and threatened Sara Thornton, had broken a window by hurling a chair through it; Sara Thornton had attempted to drug him with Mogadon in order, she stated, to get him into hospital where he might get treatment for his alcoholism] Monday, the appellant telephoned Mrs Thomas telling her she had found drink concealed in the house. She talked about the difficulties of divorce as they had only been married a short time [two months short of the one year bar to a petition for divorce] and she spoke of the difficulty of financial settlements... [Malcolm Thornton was drunk that night, and drunk and violent the next day. He ordered Sara Thornton out of the house]. Shortly afterwards she spoke on the telephone to Mrs. Thomas saying: 'I am going to have to do what I said I would do', which Mrs Thomas understood to be a reference to the threat to kill the deceased made the previous weekend (309–11).

What was formerly considered to be an understandable expression of exasperation has become a threat to kill. The court accepts as correct Mrs Thomas' interpretation of the latter statement as referring to a threat to kill; it seems equally possible that Sara

Thornton was saying that, despite all its difficulties, she would have to apply for a divorce. This is not even considered by the court.

On that evening, the evening of the homicide, Sara Thornton's behaviour leading up to the homicide is described in a form that complies with the report's construction of her as unstable, threatening and potentially violent. Note that the narrative has already dwelt in considerable detail upon an incident that happened two days before: Malcolm Thornton had threatened Sara and, apparently, her daughter. Sara Thornton had responded to this by holding a knife towards Malcolm and stating 'you touch my daughter, you bastard, and I'll kill you' (309). This was witnessed by Malcolm Thornton's son, Martin, who is said to have intervened, making Sara put down the knife. Later, Sara Thornton had attempted to get her husband committed to hospital by giving him Mogadon tablets.

That evening, Sara went out for a drink with Martin, Malcolm's son. The report states that, before leaving the house, she wrote in lipstick upon her bedroom mirror: 'Bastard Thornton. I hate you' (310). (Note that the case report repeatedly refers to 'her' bedroom; the implication is that Malcolm and Sara Thornton no longer slept together, which would function as another debit point in the legal evaluation of Sara Thornton's performance as a wife). At this point, Malcolm is said to be asleep on the couch (he had been drinking). The comments written on the mirror function within the legal narrative as evidence of a developing aggressiveness in Sara's behaviour: this is compounded by the next set of details which describe her as staying later in the pub than her step-son (no doubt inappropriate behaviour for a married woman) and being described by the taxi-driver who brought her home as 'quarrelsome and arrogant' (310). Sara Thornton is being constructed as a potentially violent actor, in this lead-up to the homicide, which occurred a short time after her return home. Malcolm Thornton, in contrast, is described as 'still sound asleep on the couch' (310); that is, harmless.

The details of the homicide are recounted as follows. Sara Thornton had changed into her nightclothes. Malcolm was lying on the sofa. The report states: 'the appellant went up to her bedroom and changed into her nightclothes. She then went down, according to her, to try to persuade the deceased to come to bed' (310). The insertion of the phrase 'according to her', for the first time in the narrative, on one level acknowledges Sara Thornton's authorial status in the event; yet at another, more compelling level, it insinuates doubt as to the purpose of Sara Thornton's behaviour at

a crucial indexical point. Legally, murder requires certain intentions or states of mind. It will be necessary for the prosecution to establish that Sara Thornton had intention to kill or cause really serious bodily harm to Malcolm. The moment of doubt allowed by the narrative as to her intention in going downstairs acts as the culmination of the construction of her behaviour as potentially violent. It permits, indeed requires, the consideration of her intention as violent. Such a requirement inflects the rest of the scene, which relates the interchange between Malcolm and Sara Thornton:

> He refused (to come to bed), called her 'a whore' and said that she had been selling her body: she was not going to get any money from him and he would kill her if she had been with other men. She said that she had only been trying to raise money for their business. She was hurt and wounded by his remarks (310).

At this point, having been abused verbally, having recently been threatened by him, having been assaulted by him in the past, she goes to the kitchen and finds a knife. This, she says, is for protection if he attacks her. Returning to the sitting-room, a further exchange takes place: 'She again asked him to come up to bed but he refused and again made wounding remarks to her saying that he would kill her when she was asleep. She then sat on the edge of the couch by his chest and said: 'Come to bed' (310). Later in the narrative, a further exchange is mentioned: 'she had said words to the effect: "if you don't come to bed, I'll kill you. Come on, this is enough. I'll kill you before you get a chance to kill me". He said: "Oh yeah, go on then. Oh yeah, go on."' (311). The narrative here builds throughout this scene on its earlier establishment of Sara Thornton's violent potential: she is in this scene positioned as violent (she sits down by his chest; that is, next to his stomach, where she stabs him); she speaks violence (in her directly reported threats which elicit Malcolm's response of, 'go on'; Malcolm's original threats to kill Sara in her sleep are not reported directly); in her seeking out the knife (she arms herself, she anticipates a violent act, she seeks to ensure the outcome of his death). After the third exchange, she stabs him in the stomach.

The history that is Sara Thornton's personal past (her previous relationships, her school-days, her behaviour, her lovers, her emotions) is inscribed in the legal narrative as a violent history. The narrative carefully represents the event and its history as incidental to the collision between victim (Malcolm Thornton) and violent actor (Sara Thornton). The violence exists in Sara Thornton's state of mind, her erratic

behaviour, her developing intention to kill, her reluctance to take the legal way out (divorce, separation), her wayward actions (alone in a pub, quarrelsome in a taxi), her failure as a wife (a previous failed marriage, her separate bedroom). Her artifice of femininity, the lipstick, allows her to inscribe her violence upon a mirror in the matrimonial home. Her femininity, however, is perceived as a device, since her violence bursts through in its language ('Bastard Thornton. I hate you'). Her pretence at maternal concern (seeking to protect her daughter from her husband's violence) is revealed as masquerade by the improper force of its expression ('you touch my daughter, you bastard, and I'll kill you'). Her charade of wifely invitation (asking Malcolm Thornton to come to bed with her) is unmasked by the irresistible violence of her desires which lead her to get a knife, to position herself, to state her lethal intent and slowly to sink the knife into Malcolm Thornton's stomach.

Law of marriage, culture of sacrifice

My aim in this section is to show how the formal contours of the narrative are produced as part of the legal culture of violence within conjugal relationships. Having recounted its story of the events leading up to the homicide, and then the homicide itself, the case report settles to the task of assessing the merits of the case, which relate to Sara Thornton's being charged with having committed murder. It does this, at one level, by evaluating the events within the formal doctrinal framework that constitutes the criminal law. For example, the court report considers the defence's arguments that Sara Thornton was provoked to kill (provocation being a defence to a charge of murder, reducing it to manslaughter) and that the trial judge put this question to the jury in an incorrect formulation. At another level, the court decides on Sara Thornton's guilt or innocence as a conjugal murderer by referring, not to the formal body of legal rules, but rather to the sacrificial body of the woman which underlies the law of marriage and the culture of violence. The remainder of this essay will discuss the second of these interpretive levels.

Law as the body of the woman

Some women have been able to plead that the fact of their having been battered by the man they have killed should reduce their culpability in the terms of the criminal law.

Thus, Kiranjit Ahluwalia, Janet Gardiner and Sally Emery have all recently had their sentences reduced, their convictions for murder changed to manslaughter.[6] Elsewhere I have argued that these changes are brought about by means of a legal discourse which constitutes the woman as victim (Young 1992). In each case the defence, the judge, the media and sometimes the prosecution have united in a portrayal of the woman as victimised by her being a battered woman, and experiencing a disorder known as 'battered women's syndrome'.[7] 'Battered women's syndrome' is a sub-category of Post-Traumatic Stress Disorder and claims to explain the nature of the woman's behaviour and state of mind at the time of and in the period leading up to the homicide. Her victimisation, as a battered woman, makes her stay in the relationship (when she should have left the abuser). It makes her continue to believe in his promises to reform after each attack (when she should have no faith left in him). It makes her take lethal action against his violence (when she should have called the police or a neighbour, left the house, left the room). In short, 'battered women's syndrome' makes an abused woman follow the wrong course each time a choice of action presents itself. Each time, she takes the unreasonable decision.[8] What, to her, seems to be a reasonable emotion (fear, terror, love, panic) or a reasonable act (staying with a partner whom she loved or loves, or committing homicide in an attempt to stay alive herself) is represented within the psycho-medical discourse of legal defences as the reasonableness of the unreasoning, the normality of the abnormal.

The Cartesian Reason that underlies criminal law remains unscathed by these cases which attribute diminished responsibility to their protagonists, thanks to evidence that they were suffering from 'battered women's syndrome' at the time of the homicide. Reason prevails, as Derrida writes, 'by excluding its contrary, that is by constituting its contrary as an object in order to be protected from it and be rid of it. In order to lock it up' (1978: 40). Reason therefore makes a sacrifice of the reasonableness of the battered woman's act, in order to preserve its own centrality, its obviousness. In the next part of this text, I will show how the dynamic of sacrifice structures not only the legal response to the battered woman who kills her abuser, as evidenced in a case such as Sara Thornton's, but also the conjugal relationship itself. Understanding the violently sacrificial nature of the conjugal relation is the only context in which we can make sense of the juridical discourse and the violent law of sexual difference.

In the cases I have mentioned above, the exclusion of the women's voices in

favour of an expert diagnosis as to their suffering from a mental disorder, enabled the categorisation of the women as victims. Sara Thornton's situation did not fit this. As I have shown above, the representation of her attitude, her conduct, her words, disqualified her from the position of victim and forced her to occupy the position of primary aggressor (despite evidence of the abuse she had suffered). If the battered woman who kills her abuser is not to be convicted and punished for murder, she must be seen by the law, and so represented by the law, as occupying the position of victim. In representing the woman as such a victim, legal discourse is repeating the dynamic relation which, according to Girard (1987), structures human relationships. Girard tells us that the human species originated in the aleatory selection of a victim whose elimination puts an end to the chaos of random violence. The violence of all against all translates into the violence of all against one, where one number is arbitrarily singled out for destruction. Upon this act of violence, the community is able to found the social contract. Girard writes: 'the victim is held responsible for the renewed calm in the community and for the disorder that preceded this return. It is even believed to have brought about its own death' (26). The victim represents the violence of the community and its subsequent peace as coming from outside, as other. The victim becomes both revered and reviled. In sacralising the victim, the community turns its violence away from itself. Thus the victim is sacralised for representing the origin of both the community and the unanimous violence that ended with the destruction of the victim. The sacred is therefore based upon a mistake which represents the effect of violence for its cause.

Girard makes no mention here of sexual difference; but I would like both to reject and to develop one aspect of his analysis by positing that the selection of a victim for sacrifice is less arbitrary than he proposes. The victim is always already Woman; her sacrifice is inevitable and necessary for the foundation of the masculine economy of representation, which produces the (illusion of the) social contract.[9] And the sacrifice of Woman is repeated over and over: modern culture, which is synonymous with sacrificial crisis as the dissolution of differences, translates Woman as a potion which will remedy harm and as a poison that it seeks to expel.[10] Thus, in the beginning was the victim, Woman, whose deferred appropriation was the first sign. To designate the victim, Woman, as both desirable and taboo is the same. The sacred, the holy and the abominable are identical and are born in the same moment, as is desire.[11] Thus Woman, as sign, speaks to us of that which is most reverenced, as the

Mother of God, and that which is most reviled, as body, flesh, blood, disease.

To designate Woman as sign is not to overlook the difference between a victim and a signifier; rather, it is to acknowledge that the victim itself is a signifier of violence.[12] As Derrida states: 'the thing itself is a sign' (1976: 49). Woman is therefore the first and most longed-for sign; and is simultaneously that which cannot be signified. As Lyotard had written, a postmodern reading is one which testifies, without nostalgia, to 'l'imprésentable', the unpresentable (1984: 369). In stating that Woman is signified as sacrifice, victim and signifier of violence, we bear witness to the unpresentable in representation itself. In analysing the manner in which the battered woman who kills is required by juridical discourse to assume the position of victim in order to reduce or avoid culpability for her act we bear witness to the unpresentable in the marriage contract: its foundation upon a relationship of violence and sacrifice. The representation of the battered woman as potential victim is a sign of the violence of the marriage relation. As Derrida's reading of Plato informs us, the scene of representation is the scene of a crime (1987: 91). The crime of the marriage contract pre-exists any violence suffered by the battered woman, or the homicide she may commit as a result of it. The crime of the marriage contract lies at its heart; in its representation of a union between two individuals.[13] To regard Woman as victim and sign is to testify to the violence which underlies this apparent union, this contractual meeting of hearts and minds.[14] When we find the object of desire in marriage, we have two violently mimetic rivals, one of whom must be the criminal and the other the victim.[15] In this phallocratic culture founded upon the sacrifice of Woman, she will always already be the victim of the violence of the marriage contract.

As I have argued, the cases in which a battered woman who kills is exonerated by the legal system are cases in which the woman appears to be the victim of the relationship. Despite her act which kills her partner, she is represented as more of a victim than the dead man. Where the woman cannot achieve this representation, she is held to have had murderous intention and it is the man who is the true victim. The severe sentences handed out to women who are convicted of marital murder – life imprisonment in Great Britain, sometimes the death penalty in the United States[16] – can be understood as a cultural (legal) reclamation of its foundational dynamic: Woman is the victim of, not the participant in, violence. A woman who dares to act violently without the redemption offered by her having the qualities of the sacrificial victim, will receive a sentence which is the juridical repetition of the

sacrifice of Woman.

I have argued that Woman as victim functioned as sign. The sign is that of the matrix of difference, the play of differences: between signifier and signified, sacred and profane, violence and peace, chaos and community (Girard 1986). Difference is the matrix of value; that is, the trace which refuses any value to Woman in marriage except as victim and sign. And the victim is the matrix of the difference between good and bad, true and false, which we can see at work in the law's judging of good and bad women, true and false victims.[17] In the moment of judgment, law reveals itself as the heir to sacrifice and its contradictions (the violent expulsion of violence). Derrida writes: '…a trial may be impossible, for by the simple fact of their articulation the proceedings and the verdict unceasingly reiterate the crime' (1987: 35).

In a society which depends on sacrifice and violence, with Woman as the favoured choice of victim, the legal system's refusal to manifest disapproval of or to enact effective measures against marital violence is simply a local strategy aimed at this end. To that extent, 'conjugal violence' is a product of law, allowed to persist and to flourish, in a condonation of the violence of the marriage relation. The law cultures violence, founds a cult of violence as sacred in marriage and acculturates individuals as violent participants in a dialectic of victim/aggressor. There is, then, a legal cult(ure) of violence in which conjugal homicide takes place. The law has permitted few remedies to be available to women who have experienced assault at the hands of their partners. It displays an extreme reluctance to intervene in any way that would provide useful options for these women; or indeed, in any way that would show that violence by men against women is not a legitimated characteristic of conjugal relations. When homicide is perpetrated by a man on his partner, the law's response is often to accommodate it within the realm of the legitimate.[18] When homicide is committed by a woman, the woman is judged according to a simplistic dichotomy between good and bad women, true and false victims. Should she fall into the category of the bad woman, the false victim, she will experience punishments of a terrifying severity: life imprisonment, the death penalty. These sentences are the logical result of the legal cult(ure) of violence which sacrifices Woman to maintain a representation of union and community in marriage; a cult(ure) which can be read, as I have shown above, in the sentences which make up the narrative of the case of Sara Thornton. The literal sentence of the court and the suspended sentences of its narrative demonstrate the operation of the legal cult(ure) of violence in its most horrifying form.[19]

Abjection and the body of Woman

The position of the victim has a tremendous power. Kristeva demonstrates this in her analysis of abjection. 'Any crime', she writes, 'because it draws attention to the fragility of the law, is abject... Abjection is immoral, sinister, scheming and shady: a terror that dissembles, a hatred that smiles, a passion that uses the body for barter instead of inflaming it, a debtor who sells you up, a friend who stabs you' (1982: 4). The battered woman, who exists in fear of death or injury at the hands of her lover, is abject; she is in the place where 'the subject, weary of fruitless attempts to identify with something on the outside, finds the impossible within; when it finds that the impossible constitutes its very being, that it is none other than abject' (5). That is, the battered woman is made abject by her being victimised and by her remaining in the position of victim (after 'fruitless attempts to identify with something on the outside'). At this point, according to Kristeva, the abject both 'beseeches and pulverises the subject' (5); is a burden both 'repellent and repelled' (6). Such is the 'fluid haze, (the) elusive clamminess' (6) of the fear that envelops the battered woman. She exists in fear, she is a victim, she is abject. And the idea of this abjection simultaneously attracts and repels; there is 'an emotionally charged fascination with abjection. Horror and fascination are here entwined' (Lechte 1990: 165).

Kristeva's writings show us the powers of horror and our desires for abjection. Within legal discourse, to argue that a battered woman who killed was suffering from 'battered woman's syndrome' demands the alignment of the battered woman with the abject. In supplement to her abjection at the hands of her lover, the law requires her to represent herself to the law as abject. Those cases in which 'battered woman's syndrome' has been accepted by the courts, are ones in which the law has been able to fix the woman in the position of the abject, the victim, the one whose desire, will, self, is submerged in fear and horror. The dramatic results that can arise out of pleading 'battered woman's syndrome' (Ahluwalia received a new trial and a suspended sentence; Emery had her sentence reduced; Gardiner was released from prison) make the strategy very seductive. However, it is my contention that this confirms the woman as victim and as abject. To argue this is to claim much more than that the law pathologises and medicalises women's bodies.[20] It is rather to argue that such results appear desirable and welcome precisely because the result is the abjection of Woman within law. We focus upon the meaning of the result, at one level, for the woman:

release from prison, a shorter sentence and so on. However, we should focus upon the process of abjection that underlies the result; as, literally, the woman is thrown away, disposed of, cast out. She is confirmed as having Unreason (rather than reason), absence (rather than identity), silence (rather than voice). She has become the Absolute Other.

It could be argued that, pragmatically, evidence as to 'battered woman's syndrome' represents a compromise made by defence lawyers in order to minimise the sentences their clients may suffer. This may indeed be a compromise, but it is one in the manner of the Faustian bargain, in which the bargainer loses at every turn. If a battered woman who kills attempts to plead that there was some reason in her act, she risks failure and a life sentence (as in Sara Thornton's case). If she compromises and pleads that she was suffering from 'battered woman's syndrome' at the time, she abjects her self to satisfy the law's desire for her victimhood. Such is the position of those women (Emery, Ahluwalia, Gardiner) who have 'benefited' from evidence as to 'battered woman's syndrome'. When a battered woman, such as Sara Thornton, is convicted of murder, her conviction and sentence represent a further order of abjection, whereby the law ensures that her victimhood can be guaranteed. To understand this, it is necessary to examine the sacrificial nature of marriage.

Caveat sponsa: conjugal sacrifice

The battered woman experiences her victimisation at the hands of her lover as abjection (as Kristeva puts it, her lover is 'a friend who stabs'). Sara Thornton's case illustrates how the legal narrative represents her as victimising her husband (she is the wife who stabs, instead of kisses; she is the mother whose milk is of ice, of lead). Instead of accepting (desiring) her abjection, Sara Thornton sought to reverse the dichotomy between herself and her violent husband. The narrative of the case inscribes the cathartic rites of the court in righting (writing) the balance (a balance which is imbalance). Thus the narrative, which I described above in detail, re-locates Sara Thornton as victim, as abject. Such a move is necessary, for the law to underwrite (restore) the sacral status of marriage. Marriage, as Cicero has it, is nature's essential human union.[21] In cases dealing with battered women who kill their partners (married women or not, the legal model of marriage acts as an archetype for all heterosexual relationships), it is the status of marriage which is at stake.

Marriage is, it seems, rather like a religion, in that the laws of marriage require faith, commitment, vows, the practice of certain behaviours, reverence, worship and sacrifice. However, this resemblance goes deeper than superficial similarity. When two people marry, they become joined in wedlock, locked together, bound. 'Spouse' has a Latin root in *conjugalis*, from *con-jungere* (to join) and *conjugalis* gives rise to the terms 'couple' and 'yoke'. 'Couple' has, of course, two senses (from Latin, *copula*), in that it connotes 'two people' and 'bind or tie'. 'Yoke' exists at literal and figurative levels, in its meanings of coupling animals together and subjection, suppression and subjugation. 'Wedlock' contains, in addition to its action of locking people together, a further bonding element: 'wed' is related to the Latin term *vas, vad-,* meaning 'surety'. Marriage is thus, linguistically, arranged as an institution of dominance and subservience, labour and bondage, ties that bind. The word 'spouse', a person who is married, derives from the Latin *sponsus, sponsa,* meaning bridegroom or bride (from *spondere*, to promise solemnly). However, it is also linked to the Latin *sponsor,* connoting one who gives a guarantee or surety. The one who is married is therefore also one who must underwrite the promise to marry and the vows of marriage with a bond or deposit or fealty.

'Marry' has a meaning beyond its obvious one (which is to enter the wedlock discussed above). 'Marry' is also the corrupt form of 'Mary', for the Virgin Mary, the Mother of God, and used in the sixteenth century in oaths (a form of promise, bonding, obligation). 'Marriage' is thus a bonding between two people and inscribed with the swearing of a duty to the Virgin Mother. This union of bondage is one that is written by contract. As Goodrich writes: 'To contract is both to include and to repress (to bury) that which can not be included as part of the system. The contract, in establishing the genre of law, acts as an antidote to other discourses' (1990: 174). The marriage contract effectively blinds us to other ways of seeing, of telling, of thinking. The contract denotes obligation, that which makes one indebted, which binds and constrains. The marriage contract joins the parties with chains (an early form of divorce was *ab vinculo*, or, from the chain, literalising the captivating and enthralling nature of marriage). In marrying, individuals bind themselves in wedlock, subjugate themselves to their obligations, as spouses.

These spouses are separated into 'husband' and 'wife'. Whereas 'wife', from Old English *wif*, means simultaneously 'woman' and 'married woman' (that is, the fact of marriage is irrelevant; all women can be classified as the same), 'husband' – in Old

151

English, *husbonda* – is ' he who is joined to a woman in marriage. It further connotes 'he who manages affairs' and 'he who is master of a house(hold)'. A hierarchy is inscribed in the semantics of the institution. The obligations of the husband relate to his mastery of the household; those of the wife relate to her being joined to the man. 'Obligation', the concept which founds the institution of marriage in its contractual nature, is owed beyond the immediate roles which accrue to the spouses. As befits a word (marry) which signifies the Virgin Mother as well as a contract to wed, 'obligation' derives from the Latin *religio*, which also gives us 'religion', and which means oath, vow, bond between man and god, scrupulousness, reverence. Here is located the semantics of the law, the order which compels fealty and obeisance to a god, a legislation, a husband. Just as law is exalted and sacralised as that which must be obeyed, so is obligation (religion) of marriage. Marriage is made holy, or sacred by our cultural order; that is, by the bonds between man and woman. And the subjugation of Woman consecrates marriage, religion, law. Woman is constituted as victim (from Latin, *victima*, one who suffers death or severe treatment; related to the Gothic *weihan*, to consecrate). Her suffering makes marriage sacred. Her suffering makes marriage holy: Woman is sacrificed (the Latin *sacer-facere*, to make holy) and thus becomes a sacrament herself (*sacramentum* in Latin, also caution money, a guarantee, a deposit or bond).

Marriage, for Woman, is therefore a contract in which her sacrifice is demanded in exchange for a spurious alteration in status (spurious because, as stated above, wife and woman are the same; the difference between them is chimeric). Woman asks for a change in status when she marries; she seeks citizenship. What is given is secondariness. She remains woman-and wife; she gains subjectivity in subjection to the mastery of her husband, and the law. The law acts as a projectile: it projects Woman into subjection, into a series of masks (sexual partner, mother, domestic servant, unwaged labourer, lover, carer), for which she is required to die.[22] She is required to suffer death or severe treatment (the victima); in return she gains a subjectivity in subjection. It is my argument that a device such as 'battered woman's syndrome', as I have outlined above, allows the woman to demonstrate her secondariness, her fealty to the sacred marriage, her abject victimhood. Sara Thornton, however, as a legal subject has reneged on her obligations as wife, as woman. She refused subjugation and acted as a subject. The law thereupon acts to re-bind her (*re-ligio*), to re-sacralise her as a victim, to simultaneously to purify and sanctify the sacred order of marriage, which is

the supreme form of contract and of the law.

In reading the legal narrative of Sara Thornton's case, I have been endeavouring to demonstrate the violence that resides within the house of the law, the house of marriage. Battered women experience not just the violence of their partners, but also of the legal order and the religious foundation of the marriage relation. At the very beginning of the case report relating to Sara Thornton's appeal, we are told that Sara Thornton 'realised from the start of their relationship that he was a heavy drinker and was jealous and possessive' (*All England Law Reports* 1992 (1): 306) Just as a consumer should take care before buying goods (*caveat emptor*), warns the court, so should a woman exercise caution when she marries; she should find a 'good man', or accept the consequences. It is my argument that women must take care over more than simply their choice of partner: within the existing legal structure, to enter the contract of marriage is to risk abjection of oneself as a woman and to subscribe to the implicit demand for the sacrifice of the woman's body. It is here that women should beware: *caveat sponsa*.

Notes

I am grateful to the following sources for funding my research on battered women who kill, of which this essay forms a part: the British Academy, the Leverhulme Trust, and the Faculty Award Program of the Canadian High Commission. My thanks also to Peter Rush, Peter Goodrich and Sally Rice for their helpful comments. McGill University's Centre for Research and Teaching on Women provided an intellectual environment which stimulated many of the ideas in this essay.

1 See, among others, Thornton 1992, reports in the press such as those that appeared in the *Guardian* on 16, 21 and 24 August 1991 and the television programme 'Murder They Said' made by 'The Heart of the Matter' and broadcast on 3 November 1991 on BBC1.

2 See the newspaper coverage of Eboli's story in the Montreal newspaper *The Gazette* on 31 March 1992.

3 See later cases such as that of Kiranjit Ahluwalia and Sally Emery; reference should also be made to the paradigmatic work of Walker (1979, 1987).

4 Incorporated within the juridical doubt as to whether Sara Thornton intended to take her *own* life is the implication that she could, in the event being considered, have intended to take another person's life.

5 See, *inter alia*, Lacey *et al.* 1990; Edwards 1989. Note that violence by parents against children has never been called 'domestic abuse'; it has always been called 'child abuse'. There are strong arguments for renaming 'domestic violence' – that is, violence by men against their intimate female partners – and referring to it as 'woman-battering' or 'woman abuse'. This argument was recently played out in London, Ontario when the Committee for the study of Family Violence voted to change its long-standing name to the Committee to End Woman Abuse.

6 Reported and discussed in the *Guardian* 27 July 1992, (Ahluwalia); 15 November 1992, (Gardiner); the *Guardian* 28 January 1992, and the *Independent* 6 December 1992 (Emery).

7 See the responses to Ahluwalia's re-trial and its verdict in the *Guardian* July and September 1992; Kennedy 1992; and compare the Justice For Women campaign which has expressed grave reservations about future judicial reliance on notions such as 'battered women's syndrome' as a means of understanding the position of battered women.

8 See Walker 1987; cf. Schneider and Jordan 1987.

9 See Pateman (1988) on the sexual contract, Irigaray (1985) on the occulting of femininity and its replacement by an idealised form of maternity and Montrelay (1978) on the destruction of the mother in Freudian psychoanalysis.

10 See further on this double movement, Derrida (1981).

11 I am here drawing on notions proposed by Freud (1939).

12 See the analysis of two photographs by Rush (1993).

13 On the contract generally, see Goodrich (1990); on the sexual contract, see Pateman (1988).

14 Kristeva (1987) provides an elegant exposition of some of these ideas in the chapter 'Romeo and

Juliet: love-hatred in the couple'.

15 For a critique of Girard's position, see Rose (1992); see further on law and sacrifice with reference to crime, Dean (1986).

16 Rapaport (1991) has analysed gender discrimination in the United States with regard to the greater proportional representation on death row of women who have committed conjugal homicides, when compared with their male counterparts; Cote (1991) has analysed sentencing in Quebec, Canada, and found that men received lesser sentences in cases of conjugal homicide; Smith (1991) claims that abolition of the mandatory life sentence for murder in English law would solve many problems in this area; that is, battered women could still be convicted of murder but would not have to go to prison for life (an argument which ignores the at least symbolic effects of conviction for murder as compared to manslaughter).

17 See Smart (1992) on the dichotomy between 'good' and 'bad' women.

18 Compare the case of Donachie *Criminal Appeal Reports* (1992) 4: 378.

19 I am borrowing the term 'suspended sentences' from Douzinas and Warrington, with McVeigh (1991).

20 Compare the approaches of Edwards (1992) on Ahluwalia's case and O'Donovan (1991) generally, on the defence of battered women who kill: both empathise the pathologisation of women's bodies.

21 As cited in Goodrich (1990: 286); note also the emphasis that society is structured like a family, like a marriage.

22 *Pro persona mori*: to die for one's mask. See the work of Goodrich (1990: 297–323).

Bibliography

All England Law Reports (1992) 1.

Browne, A. (1987) *When Battered Women Kill*, New York, The Free Press.

Cooper, D. (1992) *Amnesia*, Toronto, Random House.

Cote, A. (1991) *La Rage au Coeur: Rapport di Recherche sur le traitment Judiciaire de L'Homicide Conjugal au Quebec*, Baie-Comeau, Regroupment des Femmes de la Cote-Nord.

Criminal Appeal Reports (1992) 4: 378.

Dean, C. (1986) 'Law and Sacrifice: Bataille, Lacan, and the critique of the subject, *Representations*, 13, Winter, 42–62.

Derrida, J. (1976) *Of Grammatology*, Baltimore, Johns Hopkins University Press.

Derrida, J. (1978) *Writing and Difference*, London, Routledge and Kegan Paul.

Derrida, J. (1981) *Dissemination*, Chicago, Chicago University Press.

Derrida, J. (1987) *The Post Card: From Socrates to Freud and Beyond*, Chicago, Chicago University Press.

Douzinas, C. and Warrington, R., with McVeigh, S. (1991) *Postmodern Jurisprudence*, London, Routledge.

Edwards, S. (1989) *Policing 'domestic violence'*, London, Sage.

Edwards, S. (1992) 'Battered Women's Syndrome', *New Law Journal*, 1350.

Freud, S. (1939) *Totem and Taboo*, Harmondsworth, Penguin.

Girard, R. (1978) *Violence and the Sacred*, Baltimore, Johns Hopkins University Press.

Girard, R. (1986) *The Scapegoat*, Baltimore, Johns Hopkins University Press.

Girard, R. (1987) *Things Hidden Since The Foundation of the World*, Stanford, Stanford University Press.

Goodrich, P. (1990) *Languages of Law: From Logics of Memory to Nomadic Masks* (Law in Context), London, Wiedenfeld and Nicolson.

Irigaray, L. (1985) *Speculum of the Other Woman*, Ithaca, New York, Cornell University Press.

Kennedy, H. (1992) *Eve Was Framed*, London, Chatto and Windus.

Kristeva, J. (1982) *Powers of Horror: An Essay on Abjection*, New York, Columbia University Press.

Kristeva, J. (1987) *Tales of Love*, New York, Columbia University Press.

Lacey, N. and C. Wells, with D. Meure, (1990) *Reconstructing Criminal Law* (Law in Context), London, Wiedenfeld and Nicolson.

Lechte, J. (1990) *Julia Kristeva*, London, Routledge.

Lyotard, J.F. (1984) *The Postmodern Condition*: A Report on Knowledge, Manchester, Manchester University Press.

Montrelay, M. (1978) 'Inquiry into femininity', *m/f*, 1: 83-101.

O'Donovan, D. (1991) 'Defences for battered women who kill', *Journal of Law and Society*, November.

Pateman, C. (1988) *The Sexual Contract*, Cambridge, Polity Press.

Rapaport, E. (1991) 'On gender discrimination and the death penalty', *Law and Society Review*, 25: 124–43.

Rose, G. (1992) *The Broken Middle*, Oxford, Blackwell.

Rush, P. (1993) *The Trials of Men*, London, Routledge.

Schneider, E. M. and Jordan, S. (1987) 'Representations of women who defend themselves in response to physical or sexual assault', *Family Law Review*, 1: 118–37.

Smart, C. (1992) 'The woman of legal discourse', *Social and Legal Studies*, 1, 1: 29–44.

Smith, J. (1991) Commentary on *Rv Thornton*, Criminal Law Review, 54.

Thornton, S. (1992) 'Why I killed my husband', *Woman's Journal*, April , 100–5.

Walker, L. (1979) *The Battered Woman*, New York, Harper and Row.

Walker, L. (1987) *Terrifying Love*, New York, Harper and Row.

Young, A. (1992) 'Crime and the body', paper presented at the Law and Society Association Meeting, Philadelphia, May.

Sally Rice

tender

AND IF A MAN SMITE HIS SERVANT, OR HIS MAID, WITH A ROD, AND HE DIE UNDER HIS HAND; HE SHALL SURELY BE PUNISHED. 21 NOTWITHSTANDING, IF HE CONTINUE A DAY OR TWO, HE SHALL NOT BE PUNISHED FOR HE IS HIS MONEY. 22 IF MEN STRIVE, AND HURT A WOMAN WITH CHILD SO THAT HER FRUIT DEPART FROM HER, AND YET NO MISCHIEF FOLLOW: HE SHALL SURELY BE PUNISHED, ACCORDING AS THE WOMAN'S HUSBAND WILL LAY UPON HIM; AND HE SHALL PAY AS THE JUDGES DETERMINE. 23 AND IF ANY MISCHIEF FOLLOW, THEN THOU SHALT GIVE LIFE FOR LIFE. 24 EYE FOR EYE, TOOTH FOR TOOTH, HAND FOR HAND, FOOT FOR FOOT, 25 BURNING FOR BURNING, WOUND FOR WOUND, STRIPE FOR STRIPE. 26 AND IF A MAN SMITE THE EYE OF HIS SERVANT, OR THE EYE OF HIS

my

...RAIGHT IN THE DESERT A HIGH
...AY FOR OUR GOD. 4. EVERY
...ALLEY SHALL BE EXALTED, AND
...VERY MOUNTAIN AND HILL
...HALL BE MADE LOW: AND THE
...ROOKED SHALL BE MADE
...TRAIGHT, AND THE ROUGH
...LACES PLAIN: 5. AND THE GLORY
...F THE LORD SHALL BE REVEALED,
...ND ALL FLESH SHALL SEE IT TO-
...ETHER FOR THE MOUTH OF THE
...ORD HATH SPOKEN IT. 6. THE
...OICE SAID, CRY. AND HE SAID,
...HAT SHALL I CRY? ALL FLESH I
...RASS, AND ALL THE GOODLINES
...HEREOF IS AS THE FLOWER OF THE
...ELD: 7. THE GRASS WITHERETH
...HE FLOWER FADETH: BECAUSE
...HE SPIRIT OF THE LORD BLOWETH
...PON IT: SURELY THE PEOPLE I
...RASS. 8. THE GRASS WITHERETH
...HE FLOWER FADETH, BUT THE
...ORD OF OUR GOD SHALL STAND
...OREVER. 9. ZION THAT BRINGES

words

AND IF A MAN BORROW OUGH[T]
[OF] HIS NEIGHBOUR, AND IT B[E]
[H]URT, OR DIE, THE OWNER THEREO[F]
[BE]ING NOT WITH IT, HE SHAL[L]
[SU]RELY MAKE IT GOOD. 15. BUT I[F]
[T]HE OWNER THEREOF BE WITH I[T]
[H]E SHALL NOT MAKE IT GOOD: IF [IT BE]
[AN] HIRED THING, IT CAME FO[R]
[HIS] HIRE. 16. AND IF A MAN ENTIC[E]
[A] MAID THAT IS NOT BETROTHE[D]
[A]ND LIE WITH HER, HE SHA[LL]
[SU]RELY ENDOW HER TO BE H[IS]
[WI]FE. 17. IF HER FATHER UTTERL[Y]
[RE]FUSE TO GIVE HER UNTO HIM, H[E]
[S]HALL PAY MONEY ACCORDING T[O]
[T]HE DOWRY OF VIRGINS. 18. THO[U]
[SH]ALT NOT SUFFER A WITCH T[O]
[LI]VE. 19. WHATSOEVER LIE[TH]
[W]ITH A BEAST SHALL SURELY B[E]
[PU]T TO DEATH. 20. HE THA[T]
[SA]CRIFICETH UNTO ANY GOD, SAV[E]
[U]NTO THE LORD ONLY, HE SHA[LL]
[BE] UTTERLY DESTROYED. [21.]
[SH]ALT NEITHER VEX A [STRANGE]

dear

Note on contributors

AND ARTISTS' ACKNOWLEDGMENTS

Artists/photographers:

JANE BRETTLE is a lecturer at Edinburgh College of Art, a curator and arts administrator. She studied Fine Art at The West of England College of Art, Bristol, and Fine Art and Photography at Sunderland College of Art and the University of Derby. She has established several Photography Projects and Darkroom Workshop facilities in Scotland and is on a variety of arts advisory boards and panels. In 1988 she co-established Photography Workshop and Portfolio Gallery, Edinburgh. She is a founding director of Fotofeis (The Scottish International Festival of Photography) and was co-ordinator of the artists' project LOCATE (*Public Bodies – Private States*) of which this publication is a part.

Jane Brettle employs the temporal qualities inherent in the medium of photography to question cultural constructs from a feminist perspective. She has a particular interest in contemporary psychoanalytic and architectural theory and the critiques of language which link these to photography. Recent exhibitions include the Third Eye Centre, Glasgow (CCA) 1987, The Fruitmarket Gallery, Edinburgh 1988 and the 369 Gallery, Edinburgh and Street Level Gallery, Glasgow in 1991. She has published in a variety of magazines and educational resources.

Acknowledgments: Jane Brettle would like to thank the following: The Calouste Gulbenkian Foundation and The Hope Scott Trust for initial financial support in developing the artist's collaborative project and her work; Neil Kempsell and Andy Redman for assistance with computer imaging.

WENDY McMURDO studied Fine Art at Edinburgh College of Art and Goldsmith's College, London. She has lectured in the departments of Fine Art at Edinburgh College of Art and at Duncan of Jordanstone College of Art, Dundee. From 1987–88 she studied in the faculty of Fine Arts, Pratt University, New York and received a St Andrews Society of the State of New York Scholarship. In 1993 she received the MacDowell Fellowship, USA and the Pollock and Krasner Foundation Award, New York USA.

Wendy McMurdo uses a wide variety of photobased mediums. Her work focuses an interest in the moving image, and questions the historically determined concept of the photographic image as a re-presentation of space, alluding to the fragility of such notions. She has a specific interest in psychoanalysis and psychoanalytic film theory and the relationship of these texts to the fixed image and photography. Exhibitions include solo showings at the 369 Gallery, Edinburgh 1989 and The City Art Centre, Edinburgh 1990, and selected group exhibitions at The Fruitmarket Gallery, Edinburgh 1989, Third Eye Centre, Glasgow (CCA) 1989, and the 369 Gallery, Edinburgh 1990. Her work has been published in *Portfolio* and *Alba*

magazines and in 'Scatter', a Third Eye Centre catalogue.

Acknowledgments: Wendy McMurdo would like to thank the following funders and trusts for financial assistance: The Scottish Arts Council, The Hope Scott Trust, The Scottish International Education Trust and The Elizabeth and Isaac Wilson Trust.

SALLY RICE studied English and Philosophy at the University of York. Since graduating in 1988 she has worked in Scotland as an arts administrator, workshop tutor and writer. She was co-organiser of the artists' project LOCATE of which this publication is a part. Her work has been published in various arts journals and artists' catalogues. She is currently studying law at the University of Edinburgh.

She is interested in the processes of language through which our histories, cultural experience, identities and 'vision' are constructed. Her current work uses sound and visual texts to explore and intervene with the language of the law, and highlights the relationships between the interior and apparently private body and the public written realm of information and knowledge.

Acknowledgments: Sally Rice would like to thank Carol Robertson, Printmaker's Workshop, Edinburgh for technical work.

RUTH R. STIRLING studied Fine Art at Edinburgh College of Art. From 1985–86 she worked in the University Marine Biological Station on the Isle of Cumbrae and subsequently accepted an invitation to continue her research at the Gatty Marine Laboratory, St Andrews.

In 1988–89 she was artist in residence on the island of Igloolik in the Canadian Arctic as a recipient of the Scottish Arts Council's Richard Hough Award and a bursary from the Canadian Science Council. The following year she received the Photographer's Trust Award from the Photographers' Gallery in London. Her solo exhibition, 'Igloolik, towards the Night the Light' toured Britain in 1989–90. Part of this work was shown in 'New Scottish Photography', an exhibition and publication toured by the National Galleries of Scotland and exhibited in Spain and Germany. In 1990 she was commissioned to produce an artists' book which examined photographic technology, from orthodox microscopy to nuclear medicine, used in the National Health Service. Since 1992 she has been lecturing in the Department of Environmental Art at Glasgow School of Art.

Acknowledgments: Ruth Stirling would like to thank the following for permission to photograph: The Greek Thompson Church, The National Trust for Scotland at Crathes Castle. The episcopal Church, Isle of Cumbrae and The West Kirk, Greenock. Jonathan Robertson for photographic assistance.

The exhibition LOCATE (*Public Bodies – Private States*) featuring the work by all four artists in this publication was first shown at the Collins Gallery, Glasgow in June 1993, and was accompanied by a Conference and practical Workshops in Film-making and Computer Imaging.

THE ARTISTS would like to thank the following for financially supporting the

project: LOCATE, of which this publication is a part, The Foundation for Sport and the Arts, The Calouste Gulbenkian Foundation, The Scottish Arts Council, Glasgow City Council, Strathclyde Regional Council, Glasgow Development Agency, The Russell Trust and The Hope Scott Trust.

Writers:

CHRISTINE BATTERSBY is a lecturer in Philosophy at the University of Warwick. Since her book *Gender and Genius* was published in 1989, she has been working on a series of essays on feminist philosophy and feminist aesthetics. Many of these essays deal, as does her article in the current volume, with the problem of a female sublime. She works in an interdisciplinary way, with philosophical and feminist theory, as well as with texts from literature and painting, photography and architecture. She studied Philosophy and English at York University and Intellectual History at the University of Sussex.

Dr Battersby has a special interest in the late eighteenth century, in the philosophy of Immanuel Kant and in early Romanticism. She teaches graduate courses in Feminist Philosophy and Women's Studies, and has a commitment to theorising the works of women artists and poets. Above all, she is concerned with the role of tradition in gendering the most basic concepts of philosophy and of aesthetics.

MARY GREY holds the new chair in Contemporary Theology at the LSU College of Higher Education, Southampton. For five years she was Professor of Feminism and Christianity at the University of Nijmegen, the Netherlands, teaching courses which focused on the tensions between feminism and Christian teaching with reference to myth and contemporary literature, as well as traditional theological sources.

Professor Grey is concerned that theology genuinely engages with social issues on a global basis which includes a dialogue with third world women theologians. She is particularly involved with Creation Spirituality which evolves a lifestyle committed to right relationships between women, men and children, and the environment. She is also involved in 'Wells for India', a project established by her husband in response to the drought crisis in Rajastan, now a desert area in north-west India. Her new book *The Wisdom of Fools? Seeking Revelation for Today* explores the meaning of divine communication from a perspective grounded in 'connectedness' – with the earth and with each other.

LUDMILLA JORDANOVA is chair of History at the University of York. Her training was in the natural sciences, history and philosophy of science and art history. Professor Jordanova works on medicine from the eighteenth century onwards, especially its relations with the visual arts, on gender, and on the history of women, children and the family. Of particular interest to her is the special grip that dichotomies have exerted on generations of thinkers. Her publications include

Languages of Nature (1986) and *Sexual Visions: Images of Science and Medicine Between the Eighteenth and Twentieth Centuries* (1989).

YVE LOMAX is a visual artist and writer. She studied at St Martin's School of Art and the Royal College of Art, London. She currently lives in London and teaches at Goldsmith's College of Art and West Surrey College of Art and Design.

Her work has been exhibited widely and regularly; her numerous writings include *The World is a fabulous Tale (Other Than Itself – Writing Photography* 1989). Yve Lomax is currently working on a major photographic work, *Sometime(s)*, to be exhibited in London and published by Cornerhouse Publications in 1993.

ELIZABETH WILSON is Professor in the Faculty of Environmental and Social Studies at the University of North London. She is consultant to a variety of social, cultural and women's studies programmes within Universities and Colleges of Education throughout Britain, and has lectured widely in Britain, Holland, the USA and Canada, Denmark and Australia.

Professor Wilson has published numerous books and articles and writes regularly in the press. Her most recent publications include *The Sphinx in the City: Urban Life, the Control of Disorder and Women*, Virago Press and University of California Press, 1991, and *Pornography and Feminism: the case against Censorship*, Lawrence and Wishart, Co-editor Juliet Ash, 1992. Forthcoming publications include a novel, *The Lost Time Cafe*, Virago Press 1993, and *The Postmodern Body*, Routledge. She was a founding editorial group member of *Feminist Review* and is currently a member of the editorial board of *New Left Review*.

ALISON YOUNG is a lecturer in the Department of Law at the University of Lancaster. She is a feminist legal theorist and criminologist whose research is primarily concerned with Woman as a category in legal and cultural discourse. She is the author of *Femininity in Dissent* (Routledge, 1990), a study of the press coverage of the Greenham Common Protest. Her recent research relates to conjugal homicide, femininity, and legal and cultural representations of violence. She is completing a book on crime and modernity (*Postmodern Criminology*, to be published by Sage) and is working on a book about legal discourse and violence.

The publication
Public Bodies – Private States
New Views on Photography, Representation and Gender

is supported by
The Arts Council of Great Britain
The Foundation for Sport and the Arts
Edinburgh College of Art

List of plates

Jane Brettle

Wendy McMurdo

Elizabeth Wilson